CONSTRUCTIVE
ANATOMY

CONSTRUCTIVE ANATOMY

by

George B. Bridgman

DOVER PUBLICATIONS, INC.

NEW YORK

This Dover edition, first published in 1973, is an
unabridged republication of the work first published
in 1920 by George B. Bridgman. The present edi-
tion has been repaginated, and a new Table of Con-
tents has been added. It is here reprinted by special
arrangement with Sterling Publishing Company,
Inc., 419 Park Avenue South, New York, N. Y. 10016.

Library of Congress Catalog Card Number: 72-95434

International Standard Book Number

ISBN-13: 978-0-486-21104-6
ISBN-10: 0-486-21104-5

Manufactured in the United States by LSC Communications
21104537 2020
www.doverpublications.com

*Dedicated
to
My Mother*

THE AUTHOR desires to acknowledge his indebtedness to Dr. Ernest E. Tucker for his assistance in the preparation of the text, and to Mr. A. Wilbur Crane for his helpful suggestions.

G. B. B.

Introduction

❖

The drawings that are presented here show the conceptions that have proved simplest and most effective in constructing the human figure.

The eye in drawing must follow a line or a plane or a mass. In the process of drawing, this may become a moving line, or a moving plane, or a moving mass. The line, in actual construction, must come first; but as mental construction must precede physical, so the concept of mass must come first, that of plane second, that of line last.

Think in masses, define them in lines.

Masses of about the same size or proportion are conceived not as masses, but as one mass; those of different proportions, in respect to their movement, are conceived as *wedging* into each other, or as morticed or interlocking.

The effective conception is that of wedging.

CONTENTS

CONSTRUCTIVE
ANATOMY

General Anatomy

❀

Bones constitute the pressure system of the body. In them are expressed, therefore, laws of architecture, as in the dome of the head, the arches of the foot, the pillars of the legs, etc.; and laws of mechanics, such as the hinges of the elbows, the levers of the limbs, etc.

Ligaments constitute the retaining or tension system, and express other laws of mechanics.

Muscles constitute the contractile or power system; they produce action by their contraction or shortening. In contraction they are lifted and bulged, while in their relaxed state they are flabby and soft. Muscles, attached to and acting on the bony and ligamentous systems, constitute the motion system. In the muscles are expressed, therefore, laws of dynamics and of power.

For instance, for every muscle pulling in one direction, there must be the corresponding muscle pulling in the opposite direction. Muscles are therefore paired, throughout the body. Every muscle on the right side must be paired with one on the left; for every flexor on the front there must be its corresponding extensor on the back.

Muscles express also laws of leverage; they are large in proportion to the length of the lever they move. Those of the individual fingers are small and can fit in between the bones of the hand. They grow larger as we ascend the arm, the leverage being longer and the weight greater. The muscles of the forearm are larger than those of the fingers; those of the arm larger than those of the forearm, while the muscles of the shoulder are larger still.

Masses and Movements
of the Body

❖

The masses of the head, chest and pelvis are unchanging.

Whatever their surface form or markings, they are as masses to be conceived as blocks.

The conception of the figure must begin with the thought of these blocks in their relation to each other. They are to be thought of first as one thinks of the body of a wasp, with only one line connecting them, or without reference at all to connecting portions.

Ideally, in reference to gravitation, these blocks would be balanced symmetrically over each other. But rarely in fact, and in action never, is this the case. In their relations to each other they are limited to the three possible planes of movement. That is, they may be bent forward and back in the sagittal plane, twisted in the horizontal plane, or tilted in the transverse plane. Almost invariably, in fact, all three movements are present, to different degrees.

In these various movements, the limit is the limitation to movement of the spine. The spine is the structure that connects one part of the body with another. It is a strong column occupying almost the centre or axis of the body, of alternating discs of bone and very elastic cartilage. Each segment is a joint, whose lever extends backward to the long groove of the back. Such movement as the spine allows the muscles also allow, and are finally connected by the wedges or lines of the actual contour.

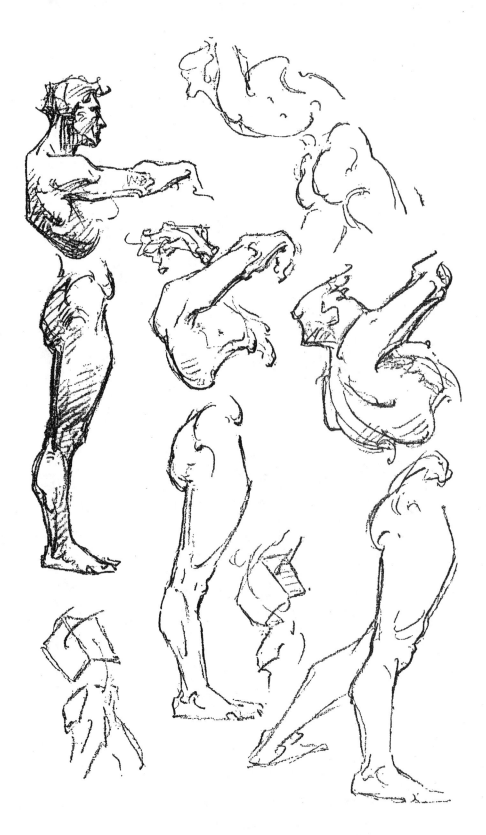

3

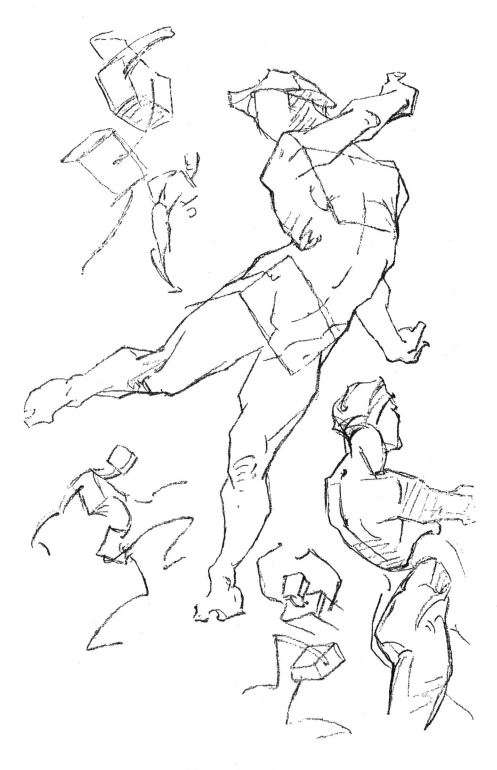

CONSTRUCTION

MASSES AND MOVEMENTS OF THE BODY:
TILTING OF THE MASSES

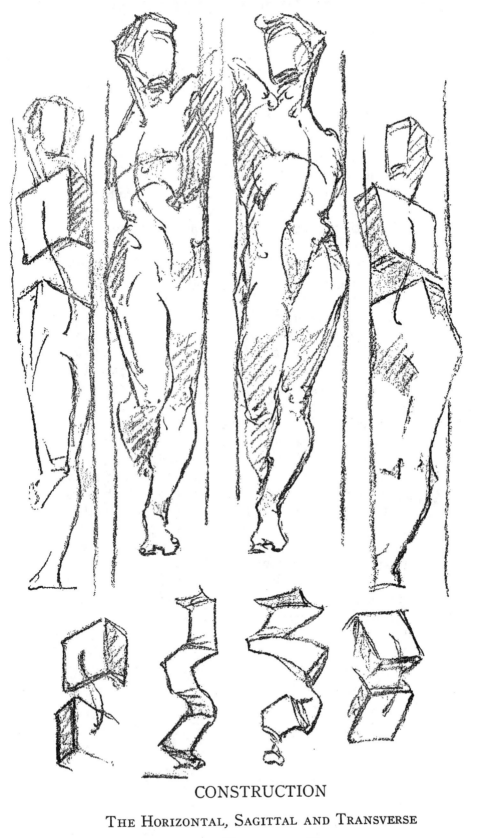

CONSTRUCTION

THE HORIZONTAL, SAGITTAL AND TRANSVERSE
PLANES: TILTED AND TWISTED

The Hand

❖

ANATOMY

In the hand are four bones, continuous with those of the fingers, called metacarpals (meta, beyond, carpus, wrist). They are covered by tendons on the back, and on the front by tendons, the muscles of the thumb and little finger, and skin pads.

There is a very slight movement like opening a fan between these bones. They converge on the wrist bones and are morticed almost solidly to them. The hand moves with the wrist. The dorsal tendons converge more sharply than the bones.

The short muscles of the hand, crossing only one joint, the knuckle, and moving the fingers individually, lie deep between the metacarpal bones and so are called interossei. They are in two sets, back and front, or dorsal and palmar. The palmar interossei are collectors, drawing the fingers toward the middle finger, and so are fastened to the inner side of each joint except that of the middle finger itself. The dorsal interossei are spreaders, drawing away from the centre, and so are fastened to both sides of the middle finger and to the outside of the other joints. In the thumb and little fingers the muscles of this set are called abductors, and being in exposed positions, are larger. That of the first finger forms a prominent bulge between it and the thumb; that of the little finger forms a long fleshy mass reaching to the wrist.

MASSES

The masses of the hand are two—one that of the hand proper, the other that of the thumb.

The first of these is beveled from knuckles to wrist on the edge; from wrist to knuckles on the flat side, and from first to little finger from side to side. It is slightly arched across the back.

Somewhat more arched are the knuckles, concentric around the base of the thumb. The second knuckle is larger and higher than the rest; the first is lower on its thumb side, where it has an overhang, as has also the knuckle of the little finger, due to their exposed positions.

Belonging to the hand is the pyramidal mass of the first segment of the thumb, which joins on at an angle, never quite flat with the hand, and bending under it to more than a right angle with its flat surface.

The thumb may be drawn in until only its root bulges beyond the lateral line of the hand, and may be carried out to a great angle with it. In this latter position its first segment forms a triangle whose base is the side of the hand, equal to it in length; whose height is, on the palmar surface, equal to the width of the hand, and on the dorsal surface, almost as great.

On the little finger side, the form is given by the abductor muscle and the overhang of the knuckle, by which the curve of that side is carried well up to the middle of the first segment of the finger.

The pad of the palm overlaps the wrist below and the knuckles above, reaching to the middle of the first segment of the fingers.

On the back of the hand, nearly flat except in the clenched fist, the tendons of the long extensors are superficial, and may be raised sharply under the skin. They represent two sets of tendons more or less blended, so are double and have connecting bands between them.

The Wrist

❖

ANATOMY

Morticed with the bones of the hand are the bones of the wrist; the two make one mass, and the hand moves with the wrist.

Eight bones (carpal bones) in two rows make the arch of the wrist; in size they are like deformed dice. The two pillars of this arch are seen on the palmar side, prominent under the thumb and the little finger. The latter is the heel of the hand, but the arch is thicker and a bit higher on the thumb side. Under it pass the long flexor tendons to the fingers and thumb.

The dome of the arch is seen on the back, with an apex at the trapezium under the first finger. It is crossed by the long extensor tendons of the fingers, which converge on its outer half.

MASSES

Its width is twice its thickness. It is narrower both ways where it joins the arm, giving an appearance of constriction.

There is always a step-down from the back of the arm, over the wrist, to the hand.

MOVEMENTS

Being solid with the hand, the wrist moves with the hand on the forearm. Its movement is like that of a boat in water; easily tipping sideways (flexion and extension) with more difficulty tilting endways (side-bending) which in combination give some rotary movement, but having no twisting

movement at all. This movement is accomplished by the forearm.

The inset of this boat-shaped joint with the arm gives the appearance of constriction. The prow, under the thumb, is higher than the stern under the little finger.

When fully extended, the back of the hand with the arm makes almost a right angle; when fully flexed, the palmar surface makes almost a right angle; the total movement therefore is slightly less than two right angles.

When the wrist is fully flexed, it forms at the back a great curve over which the extensor tendons are drawn taut, so much so that the fingers can never be closed when the wrist is fully flexed. In this position the flexor tendons are raised prominently under the skin.

When hand and arm lie extended along a flat surface, it is the heel of the hand that is in contact, the arm bones being lifted from the surface.

To the four corners of the wrist are fastened muscles; two in front (flexor carpi radialis and flexor carpi ulnaris) and two behind (extensor carpi radialis and extensor carpi ulnaris, the former being double). By their contraction the wrist is moved in all directions, except twisting, which movement is produced not in the wrist but in the forearm. Only the tendons cross the wrist, the muscular bodies lying in the forearm.

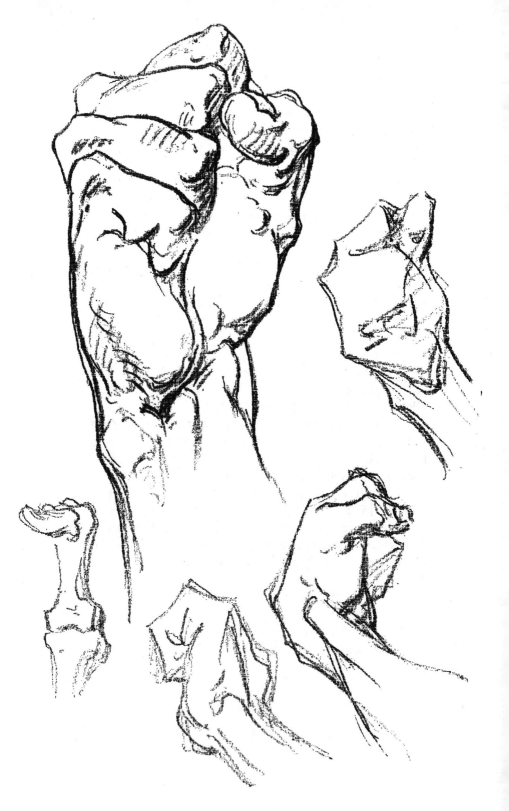

THE HAND

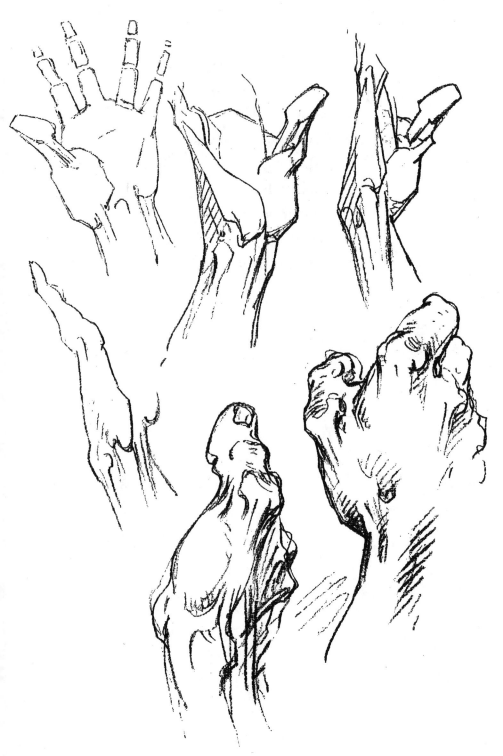

THE HAND

THE HAND

Muscles of the Hand, front palmar

1 Abductor pollicis.

2 Flexor brevis pollicis.

3 Abductor transversus pollicis.

4 Lumbricales.

5 Annular ligament.

6 Flexor brevis minimi digiti.

7 Abductor minimi digiti.

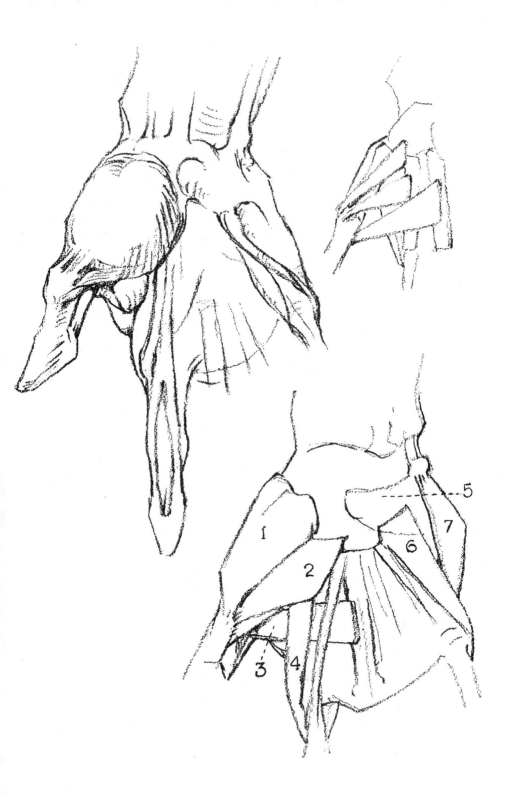

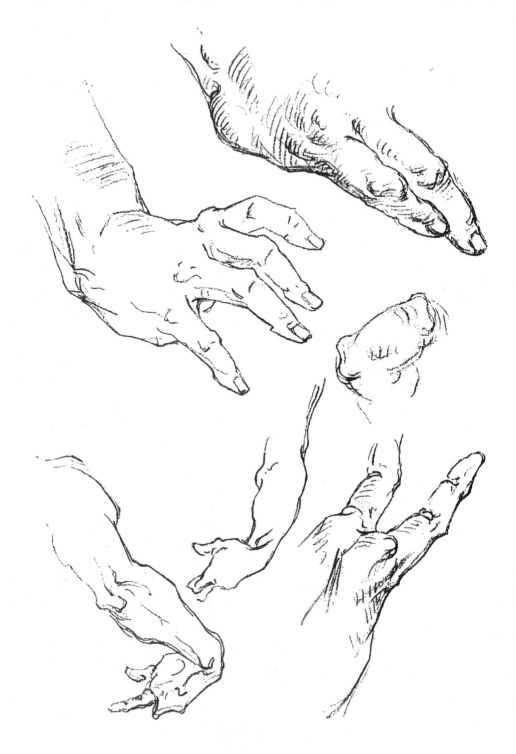

THE HAND

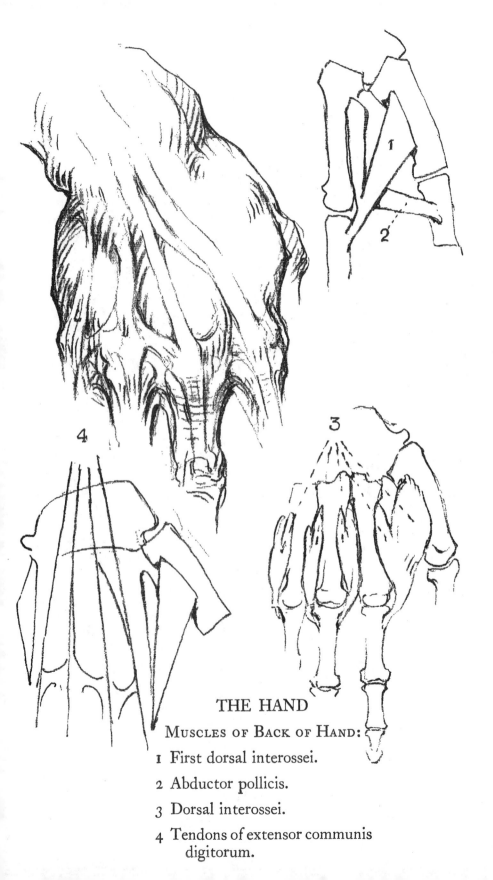

THE HAND

Muscles of Back of Hand:

1 First dorsal interossei.

2 Abductor pollicis.

3 Dorsal interossei.

4 Tendons of extensor communis
digitorum.

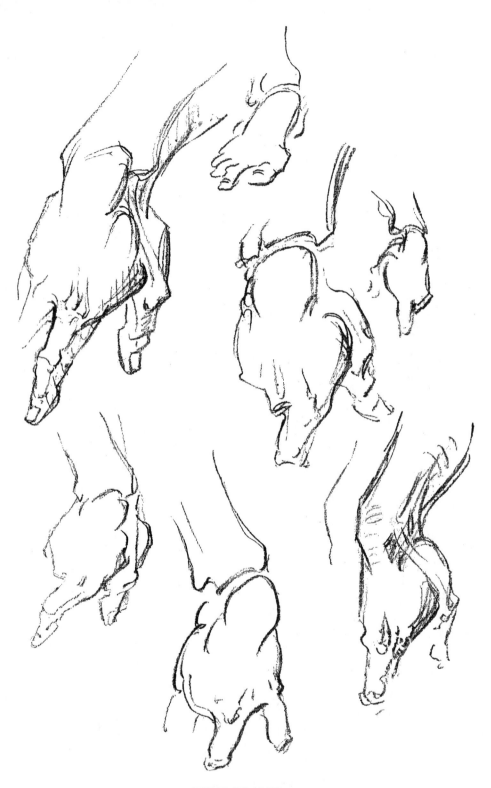

THE HAND

WEDGING OF THE WRIST: THUMB SIDE

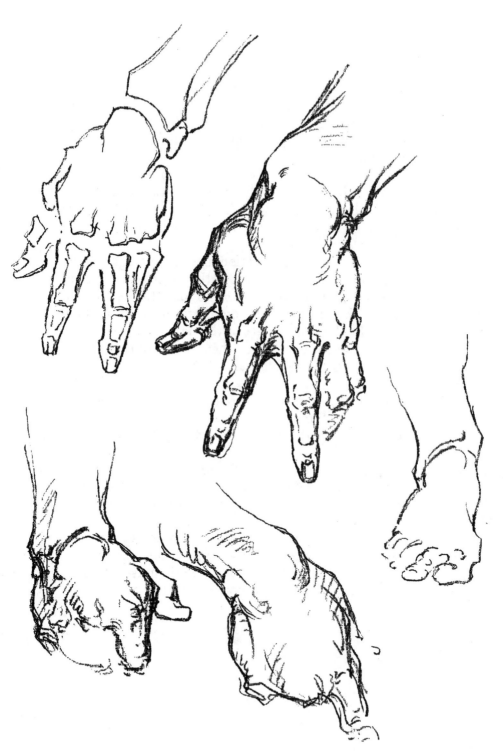

THE HAND

WEDGING OF THE WRIST: LITTLE FINGER SIDE

THE HAND

In the hand as in the figure there is an action and an inaction side. The side with the greatest angle is the action side, the opposite is the inaction or straight side.

With the hand turned down (prone) and drawn toward the body, the thumb side is the action side, the little finger the inaction side. The inaction side is straight with the arm, while the thumb is almost at right angles with it.

The inaction construction line runs straight down the arm to the base of the little finger. The action construction line runs down the arm to the base of the thumb at the wrist, from there out to the middle joint, at the widest part of the hand; thence to the knuckle of the first finger, then to that of the second finger, and then joins the inaction line at the little finger.

With the hand still prone, but drawn *from* the body, the thumb side is the inaction side, and is straight with the arm, while the little finger is at almost right angles with it. The inaction construction line now runs straight to the middle joint of the thumb, while the action line runs to the wrist on the little finger side, thence to the first joint, etc., etc.

These construction lines, six in number, are the same with the palm turned up, according as it is drawn in or out. They place the fingers and indicate the action and proportions of the hand.

18

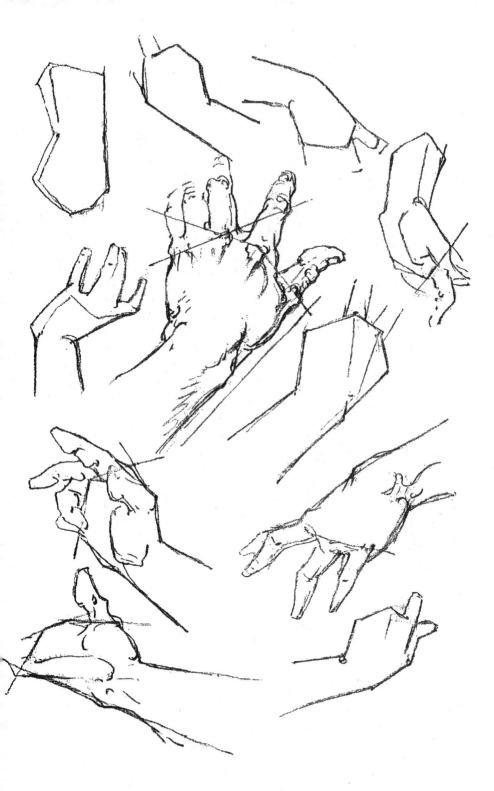

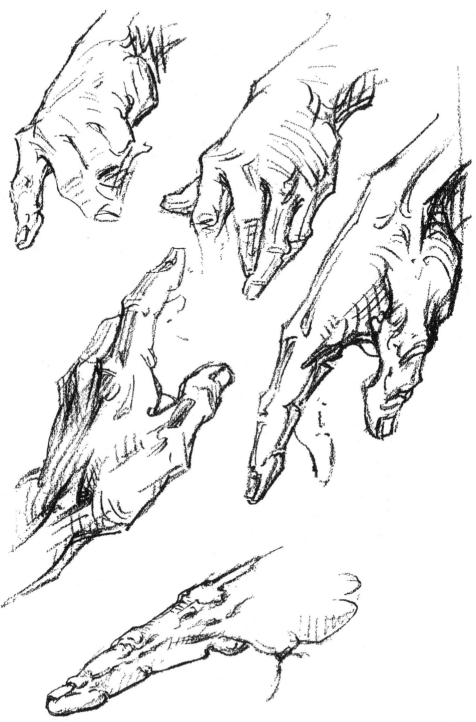

THE HAND

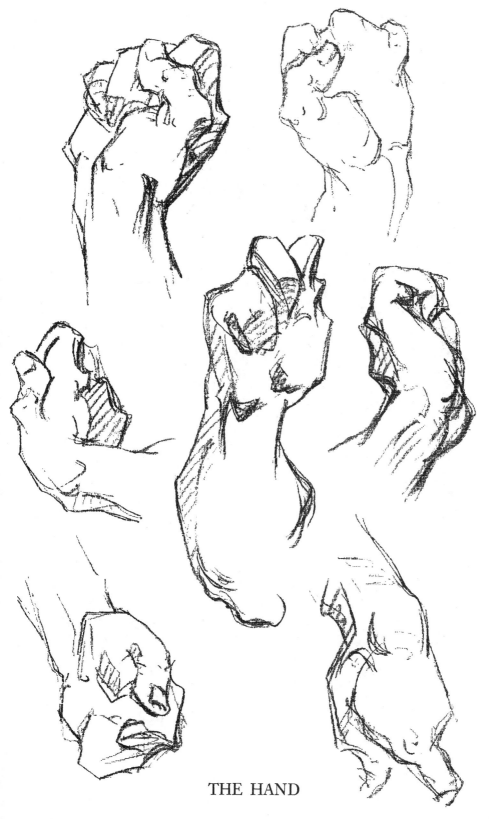

THE HAND

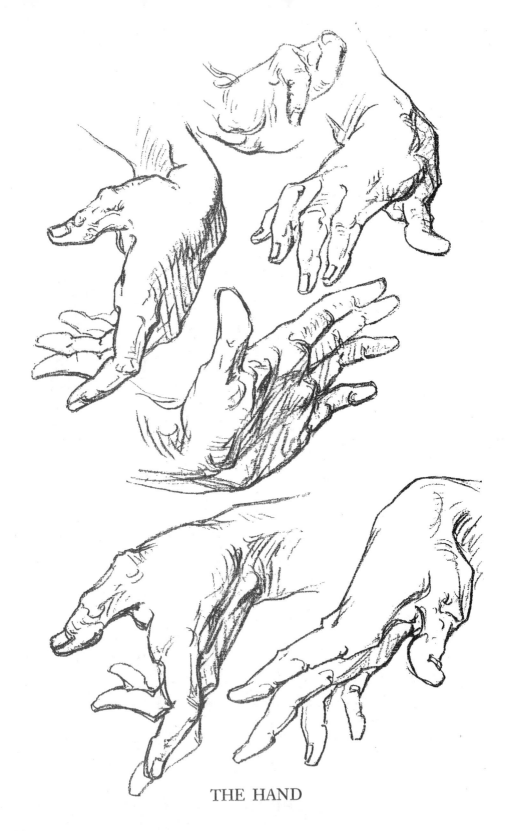

THE HAND

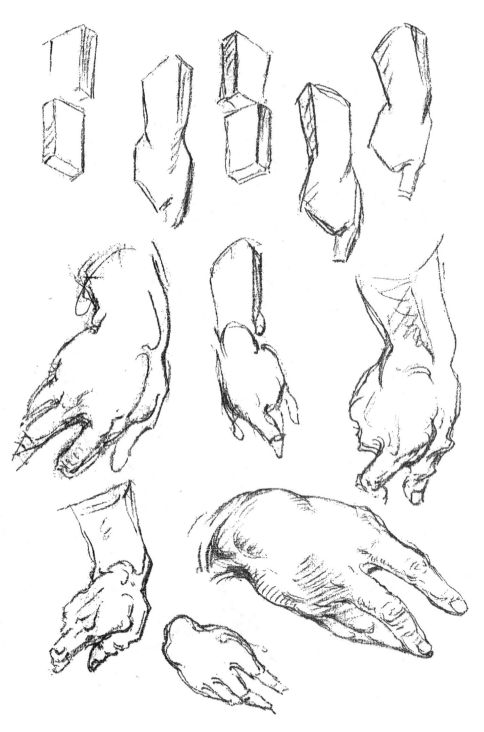

THE HAND

Turning of the Masses of Hand and Wrist

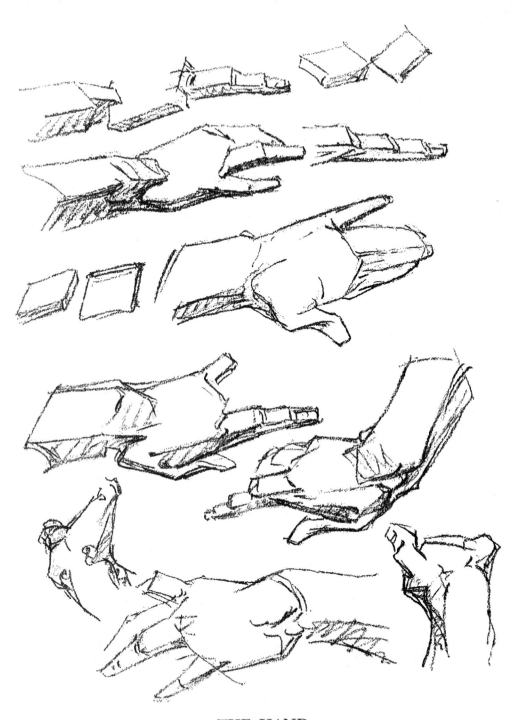

THE HAND

MASSES OF FINGERS, HAND AND WRIST:
STEP-DOWN, WEDGING, INTERLOCKING

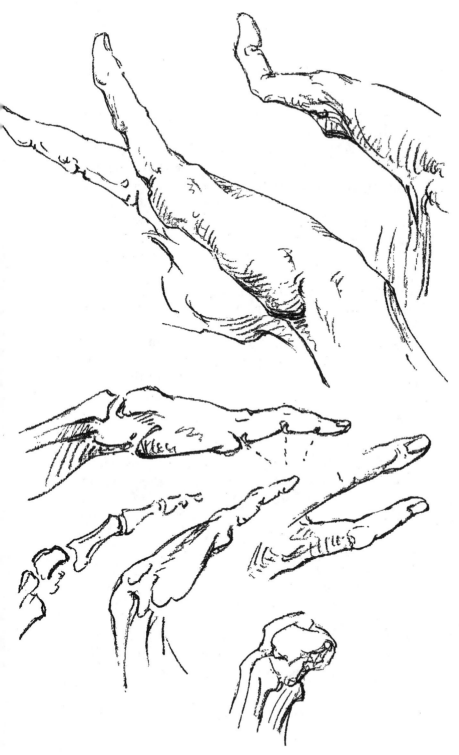

THE HAND
INTERLOCKING OF HAND AND WRIST:
LITTLE FINGER SIDE

The Thumb

❁

Drill master to the fingers, the hand and the forearm, is the thumb.

The fingers, gathered together, form a corona around its tip. Spread out, they radiate from a common centre at its base; and a line connecting their tips forms a curve whose centre is this same point. This is true of the rows of joints (knuckles) also.

Bent, in any position, or closed as in clasping, the fingers form arches, each one concentric on this same basal joint of the thumb. Clenched, each circle of knuckles forms an arch with the same common centre.

The mass of the thumb dominates the hand.

The design and movement of even the forearm is to give the freest sweep to the thumb; while, through the biceps muscle, its movement is seen to begin really at the shoulder.

ANATOMY

The thumb has three segments and as many joints. Its bones are heavier than those of the fingers, its joints more rugged.

Its last segment has a nail and a heavy skin pad. The middle segment has only tendons. The basal segment is a pyramidal mass of muscle reaching to the wrist, the "line of life" of the palm, and the base of the first finger.

The superficial muscles of this mass are a fat one, a broad one, and a thin one. The fat muscle hugs the bone (opponens), the broad one forms the bulk of the pyramid (abductor) and the thin one lies inside, toward the index finger (flexor brevis).

Between the thumb and first finger the skin is raised into a web, which is bulged, especially when the thumb is flattened, by the adductor pollicis muscle.

MASSES

The thumb is pyramidal at the base, narrow in the middle, pear-shaped at the end. The ball faces to the front more than sideways. It reaches to the middle joint of the first finger.

The last segment bends sharply back, carrying the nail. Its skin pad, broad at the base, gives it an appearance not unlike a foot, expressing its pressure-bearing function.

The middle segment is square with rounded edges, smaller than the other two, with a small pad.

The basal segment is rounded and bulged on all sides except where the bone is superficial at the back.

MOVEMENTS

The last joint has about one right angle of movement, in one plane, and may by pressure be twisted toward the fingers.

The heavy middle joint moves less freely, also limited to one plane.

The joint of the base is a saddle joint, with movement like one in a saddle, that is, with easy bending sideways, less easy forward and back; which two in combination give some rotary movement, but giving a twisting movement only with difficulty and strain.

THE THUMB

Extensors of the Thumb:

1 Extensor ossis metacarpi pollicis.

2 Extensor brevis pollicis.

3 Extensor longus pollicis.

THE THUMB

MUSCLES OF THE THUMB, palmar view:

1 Flexor brevis pollicis.

2 Abductor pollicis.

3 Apponens pollicis.

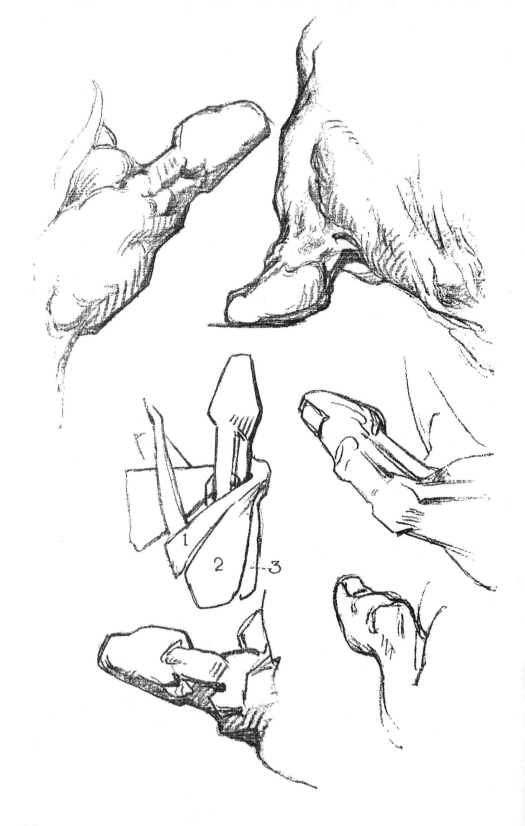

1
2
3

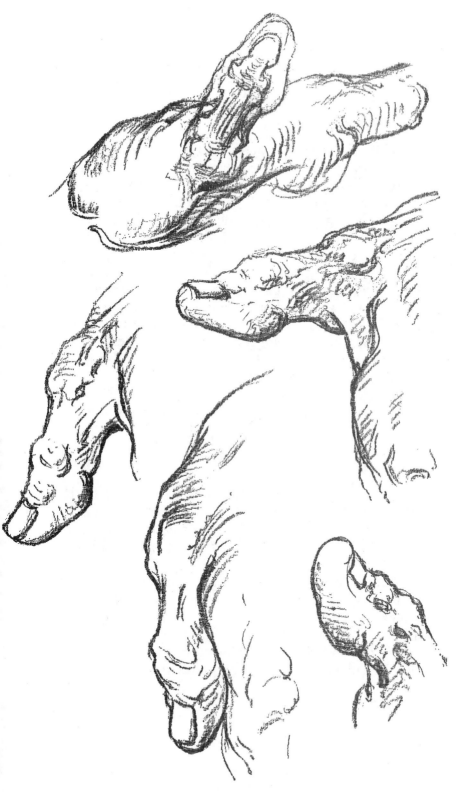

THE THUMB

The Fingers

❀

ANATOMY

Each of the four fingers has three bones (phalanges, soldiers). Each phalanx turns on the one above, leaving exposed the end of the higher bone. There are no muscles below the knuckles; but the fingers are traversed by tendons on the back, and are covered on the front by tendons and skin pads.

The middle finger is the longest and largest, because in the clasped hand it is opposite the thumb and with it bears the chief burden. The little finger is the smallest and shortest and most freely movable for the opposite reason. It may move farther back than the other fingers, and is usually held so, for two reasons; one is that the hand often "sits" on the base of the little finger; the other is that being diagonally opposite the thumb it is twisted farther backward in any outward twisting movement, and so tends to assume that position.

MASSES

All bones of the body are narrower in the shaft than at either end, especially those of the fingers. The joints are square, the shafts smaller but square, with rounded edges; the tips are triangular. The middle joint of each finger is the largest.

In the clenched fist it is the end of the bone of the hand (metacarpal) that is exposed to make the knuckle. The finger bone (first phalanx) moves around it, and bulges beyond. The extensor tendon makes a ridge on the knuckle and connects it with the first phalanx; but on the middle and the last

joints the tendon makes a depression or groove in the centre of the joint.

The masses of these segments are not placed end to end, as on a dead centre, either in profile or in back view. In the back view, the fingers as a whole arch toward the middle finger.

In the profile view, there is a step-down from each segment to the one beyond, bridged by a wedge.

A series of wedges and squares thus marks the backs of the fingers. Into the square of the knuckles a blunt wedge is seen to enter from above. From it a long tapering wedge arises and enters the square of the middle joint, from which a blunt wedge also reaches backward. Another tapering wedge arises here and moves half way down the segment. The whole finger tapers from the middle joint, to become embedded in a horseshoe form holding the nail. This form begins back of the root of the nail and bevels to below its end, at the tip of the finger. The whole last segment is a wedge.

The palmar webbing opposite the knuckles, which reaches to about the middle of the first segment of the finger, in front, bevels backward and points to the top of the knuckle in the back.

The segments of individual fingers are of different lengths, those of the middle finger being longest. From tip to base, and on into the bones of the hand, the segments increase in length by definite proportions.

MOVEMENTS

Each joint moves about one right angle except the last, which moves slightly less; and limited to one plane, except the basal, which has also a slight lateral movement, as in spreading the fingers.

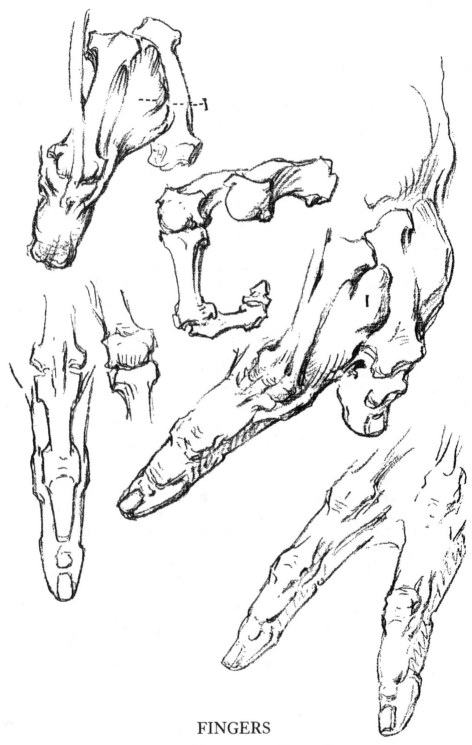

FINGERS

PAD BETWEEN THUMB AND FIRST FINGER:
1 First dorsal interosseus.

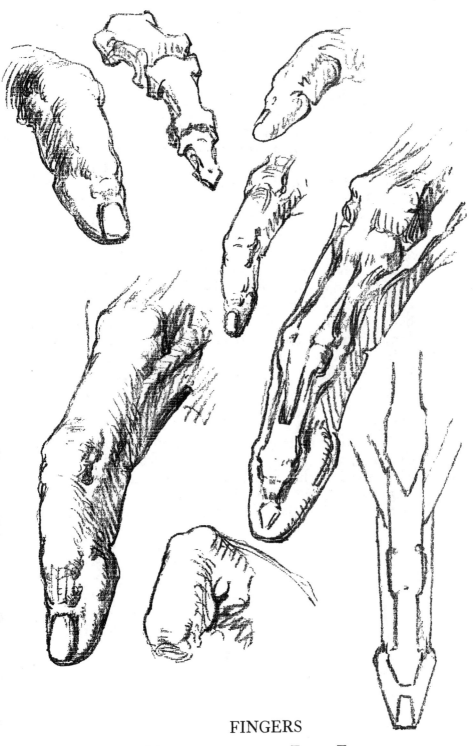

FINGERS

Mechanism of the First Finger

FINGERS

CREASES

While the segments of any finger, seen on the back, are of different lengths, the pads seen on the palmar side are of the same length, including the pad of the base which is part of the palm, so that the creases between them are not all opposite the joints. The reason is immediately seen when the finger is viewed closed on itself. The creases are then seen to form a cross, the pads to meet in the common centre, filling in the four sides of a diamond.

In the first finger the creases are: short of the last joint; opposite the middle joint; half way between middle and basal joint, and opposite the basal knuckle (above the joint proper, which is considerably beyond the point of the knuckle).

In the second finger they are: opposite the last joint; beyond the middle joint; midway between middle and basal joint, and opposite the basal joint.

In the other fingers they vary in different individuals.

The creases are all transverse except that opposite the basal joint, which forms one long wavy crease on the palm; and those next beyond, on first and little fingers, which slope down on the outside, in the spread fingers making a curve around the base of the thumb.

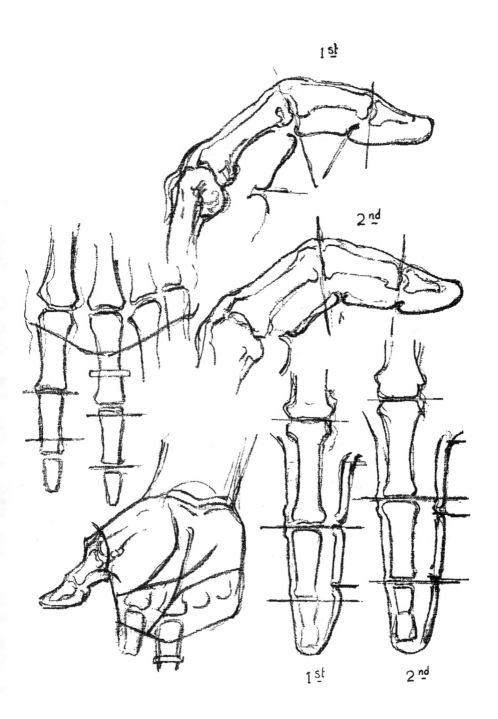

1<u>st</u>

2<u>nd</u>

1<u>st</u>

2<u>nd</u>

37

FINGERS

1 Dorsal interossei of the hand.

2 Tendons, finger, dorsal side.

3 Tendons, finger, palm side.

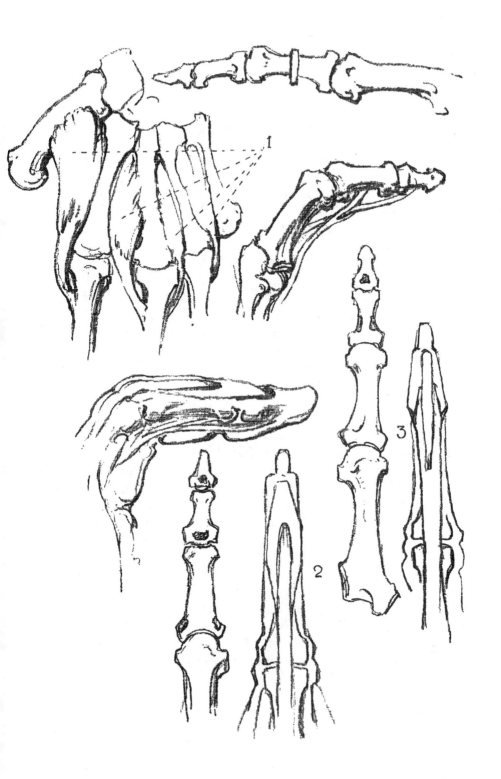

The Forearm

❀

In the forearm are two bones, lying side by side. One is large at the wrist, forming two-thirds of the joint; the other is large at the elbow, where it also forms two-thirds of the joint. They are joined at their sides and move like a long piece of cardboard folded diagonally.

The one that is large at the elbow is the ulna. It forms a hinge joint and moves in the bending of the elbow. The other slides as the hinge moves. This second bone is the radius, or turning bone; it is large at the wrist and carries the wrist and hand.

Diagonally opposite the thumb, on the ulna, is a hump of bone which is the pivot for both the radius and also the thumb.

Muscles must lie above the joint they move, so that the muscles that bulge the forearm are mainly the flexors and extensors of the wrist and hand. Overlying them and reaching higher up on the arm are the pronators and supinators of the radius.

The flexors and pronators (flexor, to flex or bend; pronator, to turn face down, or prone) form the inner mass at the elbow, the extensors and supinators form the outer mass. Between them at the elbow lies the cubital fossa.

Both of these masses arise from the condyles of the humerus, or arm bone. These are the tips of the flattened lower end of that bone. From the inner condyle, which is always a landmark, arises the flexor-pronator group. This is a fat softly bulging mass which tapers to the wrist, but shows

superficially the pronator teres (round), whose turning function requires it to lie diagonally across toward the thumb side.

The outer condyle is hidden by its muscular mass when the hand is turned out. This mass is the extensor-supinator group, which bulges higher up, and becomes tendinous half way down. It is dominated by the supinator longus, which rises a third of the way up the arm, widens as far as the elbow, tapers beyond, and loses itself half way down the forearm. In turning, this wedge follows the direction of the thumb, and overlies the condyle when the arm is straight with the forearm.

From the back view, the elbow is seen to have three knobs of bone; the two condyles above referred to, and between them the upper end of the ulna, forming the elbow proper, or olecranon. The latter is higher when the arm is straight and lower when it is flexed. The overlying muscular masses meet over half way down, so that the ulna forms a thin dagger of bone pointing to the little finger.

Masses

The masses of the forearm will be described in connection with those of the arm and shoulder.

The Arm

❖

Anatomy

The bone of the upper arm is the humerus. The part facing the shoulder is rounded and enlarged to form the head, where it joins the shoulder blade. The lower end is flattened out sideways to give

[69]

attachment to the ulna and radius, forming the condyles. The shaft itself is straight and nearly round, and is entirely covered with muscles except at the condyles.

On the flat front side of the condyles, reaching half way up the arm, is placed the broad, flat and short brachialis anticus muscle; and on top of that the thin, high and long biceps, reaching to the shoulder; its upper end flattened as it begins to divide into its two heads. One head passes to the inside of the bone and fastens to the coracoid process, under the shoulder; the other passes outside, grooving the head of the humerus, and attaching to the shoulder blade above the shoulder joint, under the deltoid or shoulder hood.

On the back, behind the flat surface made by the two condyles, arising from the central knob or olecranon, is the triceps (three-headed) muscle. Its outer head begins near the condyle, and occupies the outer and upper part of the back surface of the humerus. The inner head begins near the inner condyle and occupies the inner and lower portion of the bone. The middle head reaches diagonally in and up to the back of the shoulder blade. These all converge on the broad flat tendon from the olecranon, forming a wedge surrounded by two wings of muscle. The triceps also is overlaid by the deltoid above.

Between biceps and triceps are grooves. The inner condyle sinks into the inner groove below, and it is filled out above by the coraco-brachialis muscle, entering the armpit.

The outer condyle sinks into the outer groove below, while midway of the arm the apex of the deltoid muscle sinks into it, overlying the upper ends of both biceps and triceps.

BONE OF THE ARM:

1 Humerus.

BONES OF THE FOREARM:

2 Ulna (little finger side).

3 Radius (thumb side).

THE ARM

Humerus—arm.

Radius—forearm, thumb side.

Ulna—forearm, little finger side.

Muscles of the Upper Limb, front view:

1 Coraco-brachialis.

2 Biceps.

3 Brachialis anticus.

4 Pronator radii teres.

5 Flexors, grouped.

6 Supinator longus.

Coraco-brachialis: From coracoid process, to humerus, inner side, half way down.
Action: Draws forward, rotates outward, humerus.

Biceps: Long head from glenoid cavity (under acromion) through groove in head of humerus; short head from coracoid process; to radius.
Action: Depresses shoulder blade; flexes forearm; rotates radius outward.

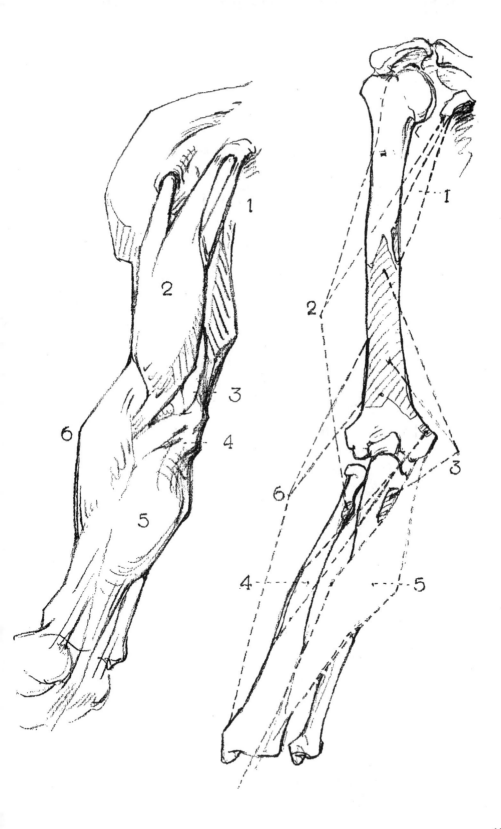

45

THE ARM

SUPINATION AND PRONATION OF THE FOREARM,
front view:

1 Supinator longus.

2 Pronator radii teres.

3 Flexors, grouped.

Supinator Longus: From external condyloid ridge
to end of radius.
Action: Supinates forearm.

Pronator Radii Teres: From internal condyle and
ulna to radius, outer side, half way down.
Action: Pronates hand and flexes forearm.

Flexor group, page 60

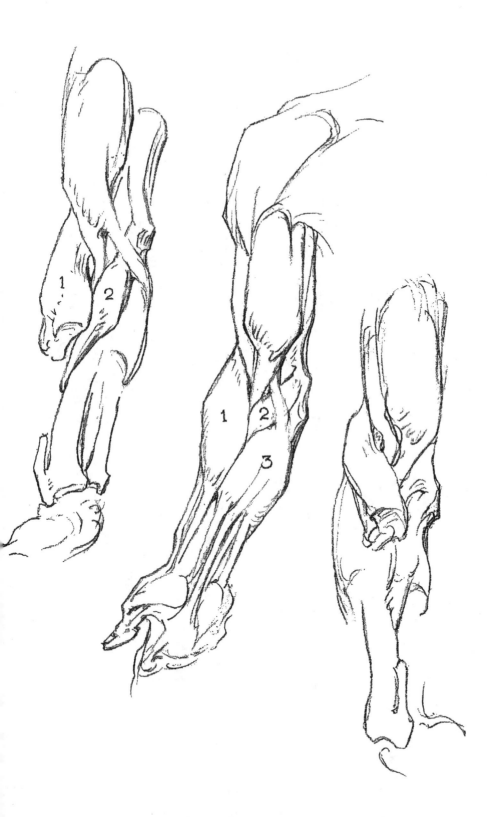

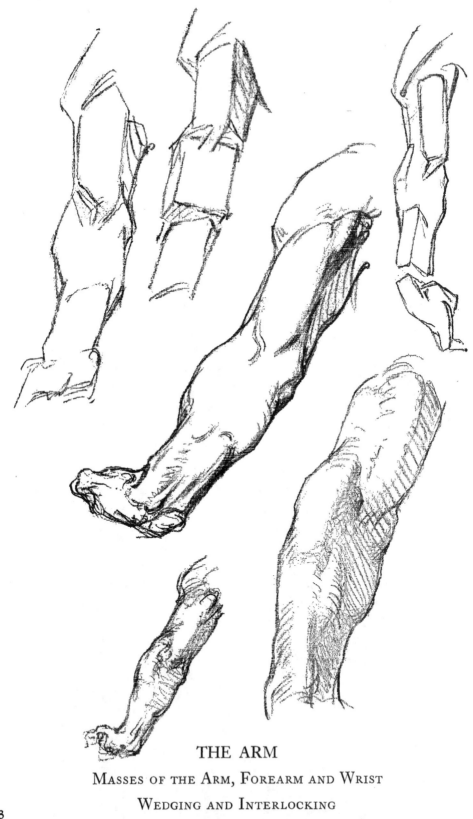

THE ARM

MASSES OF THE ARM, FOREARM AND WRIST

WEDGING AND INTERLOCKING

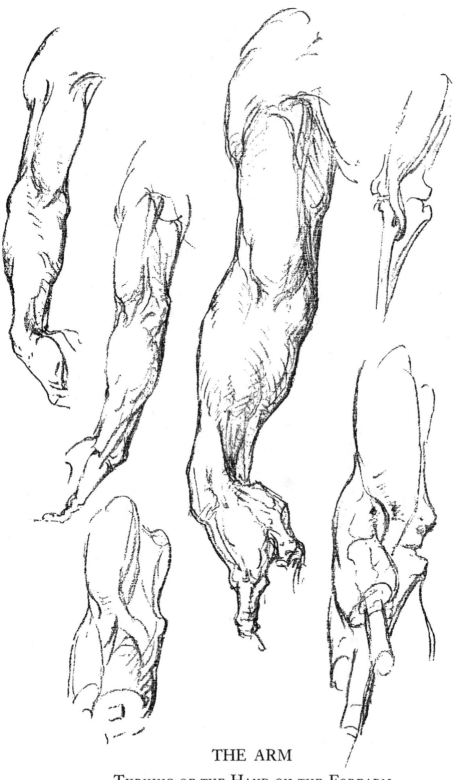

THE ARM

TURNING OF THE HAND ON THE FOREARM
AND THE FOREARM ON THE ARM

49

THE ARM

(thumb side toward the body):

1 Coraco-brachialis.

2 Biceps.

3 Brachialis anticus.

4 Supinator longus.

5 Extensor carpi radialis longior.

6 Pronator radii teres.

7 Flexors, grouped.

Brachialis Anticus: From front of humerus, lower
 half, to ulna.
Action: Flexes forearm.

Extensor Carpi Radialis Longior: From external
 condyloid ridge to base of index finger.
Action: Extends wrist.

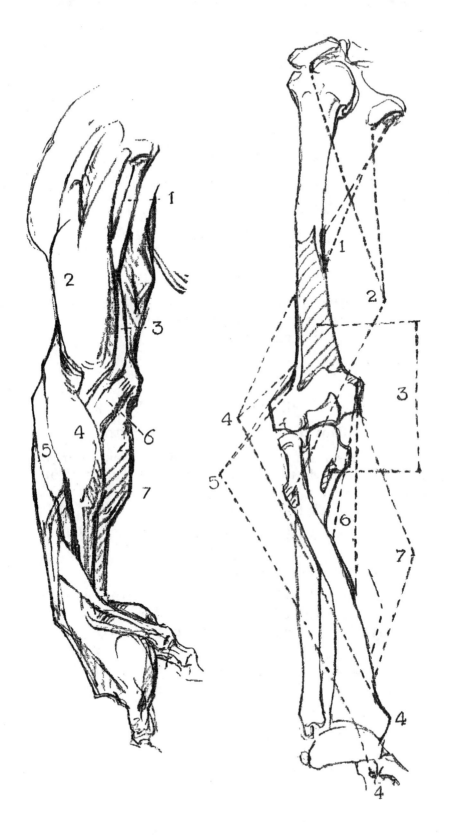

51

THE ARM

1 Triceps.

2 Supinator longus.

3 Extensor carpi radialis longior.

4 Anconeus.

5 Extensors, grouped.

Anconeus: From back of external condyle to ole-
cranon process and shaft of ulna.
Action: Extends forearm.

EXTENSOR GROUP

From External Condyle of Humerus

Extensor Digitorum Communis: From external
condyle to second and third phalanges of all
fingers.
Action: Extends fingers.

Extensor Minimi Digiti: From external condyle to
second and third phalanges of little finger.
Action: Extends little finger.

Extensor Carpi Ulnaris: From external condyle
and back of ulna to base of little finger.
Action: Extends wrist and bends down.

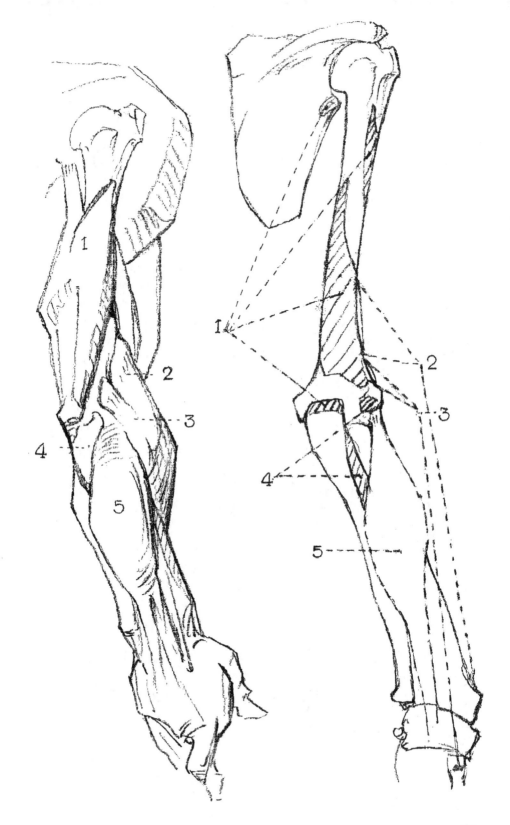

THE ARM

Muscular Mass of Forearm, back view:

1 Extensor carpi ulnaris.

2 Extensor communis digitorum.

Extensor group, page 52.

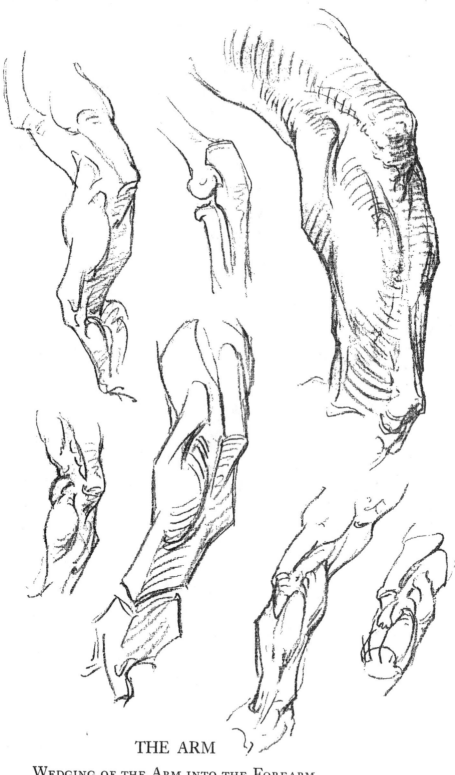

THE ARM

WEDGING OF THE ARM INTO THE FOREARM,
back view

THE ARM

Wedging of Arm into the Forearm
at the Elbow:

1 Biceps.

2 Triceps.

3 Supinator longus.

4 Flexors

5 Extensors.

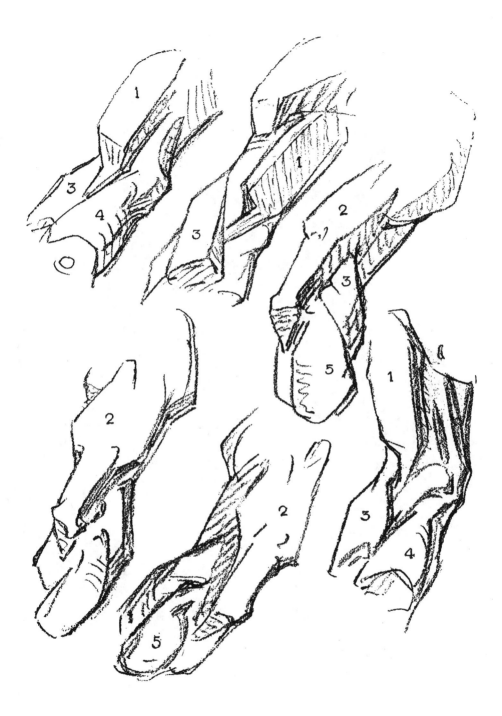

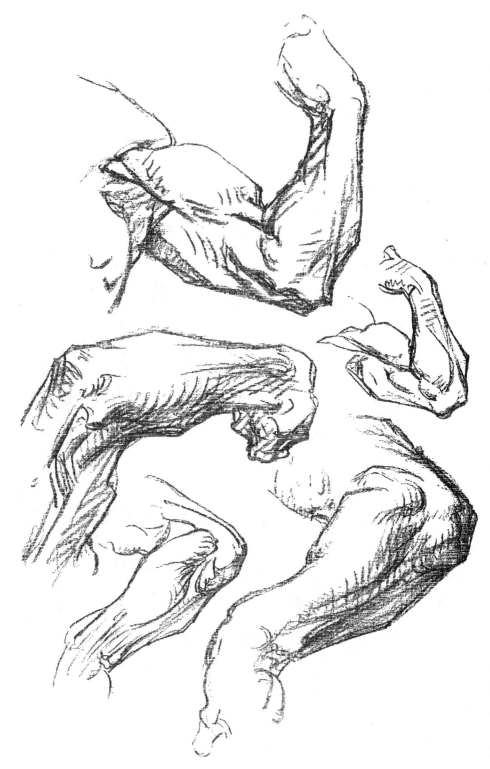

THE ARM

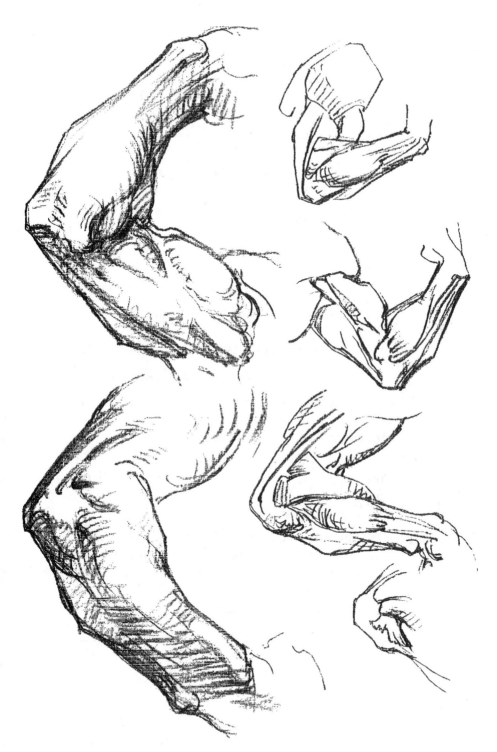

THE ARM

THE ARM

<small>MUSCLES OF THE ARM</small>, inner view:

1 Triceps.

2 Biceps.

3 Supinator longus.

4 Flexors, grouped.

5 Pronator teres.

FLEXOR GROUP

<small>FROM INTERNAL CONDYLE OF HUMERUS</small>

Flexor Carpi Radialis: From internal condyle to first metacarpal.
Action: Flexes wrist and bends up.

Flexor Carpi Ulnaris: From internal condyle and olecranon to fifth metacarpal, base of little finger.
Action: Flexes wrist and bends down.

Flexor Sublimis Digitorum (flexor sublimis perforatus): From inner condyle, ulna and radius to second phalanges of all fingers; perforated to admit passage of profundus tendons.
Action: Flexes fingers and hand.

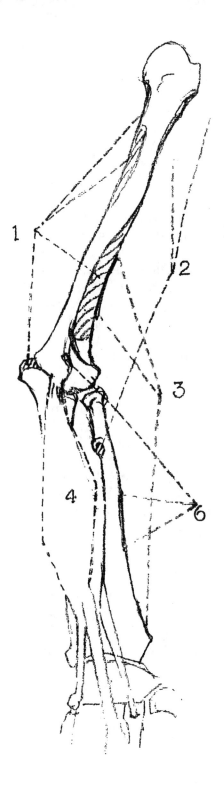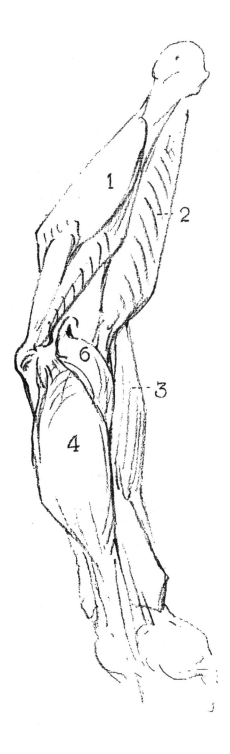

61

The Shoulder

❁

ANATOMY

Form is given to the shoulder by the deltoid (triangle) muscle.

An almost perfect triangle is this muscle, its apex downward and wedging into the outer groove of the arm, its base upward and bent around to attach to the shoulder girdle. Just below the base is a ripple which marks the head of the arm bone.

The shoulder girdle is made up of the collar bone and a ridge of the shoulder blade, meeting. They both point outward, the ridge a bit the lower, but both turn straight forward before meeting.

The collar bone is an S-shaped bone, its outer curve and tail made by this forward turning. Over the point of union is a flat space. From the hollow of this S-curve a groove sinks first downward and then at an angle outward, marking the border between the shoulder and the great breast muscle.

Behind the inner two-thirds of the collar bone is a triangular depression between it and the trapezius muscle behind; its base to the neck, its apex pointing outward.

MOVEMENTS

In the shoulder are found two joints. At the point of the shoulder is the joint between shoulder blade and collar bone, a flat hinge pointing straight forward, allowing the shoulder blade to slide freely over the flat surface of the back.

Not only may the shoulder blade slide freely over

the back, but may even lift from it at the point and inner edge, slightly amplifying its range.

Below it under the deltoid is the joint of the shoulder blade with the humerus or arm bone, the shoulder proper, facing sideways and a little forward. It is a universal joint, with a right angle and a half of movement in two planes; but its sweep is always increased by the movement of both shoulder blade and collar bone.

At the juncture of the collar bone with the sternum or breast plate is a universal joint, with movement in two planes and also twisting, but with very narrow range. Its movements are chiefly lifting forward and up and twisting forward. Its shape expresses an important spring function, it being the only bony union of arm and shoulder with the trunk.

MASSES

The masses of the shoulder, arm, forearm and hand do not join directly end to end with each other, but overlap and lie at various angles. They are joined by wedges and wedging movements.

Constructing these masses first as blocks, we will have the mass of the shoulder, or deltoid muscle, with its long diameter sloping down and out, beveled off at the end; its broad side facing up and out; its narrow edge straight forward.

This mass lies diagonally across and overlaps the mass of the arm, whose long diameter is vertical, its broad side outward, its narrow edge forward.

The mass of the forearm begins behind the end of the arm and passes across it at an angle forward and out. It is made of two squares. The upper half of the forearm is a block whose broad side is forward, its narrow edge sideways; while the lower

half, smaller than the upper, has its narrow edge forward, its broad side facing out (with the hand held thumb up).

These blocks are joined by wedges and wedging movements, and to the straight lines are wedded the curved lines of the contour of the muscles. The deltoid is itself a wedge, whose apex sinks into the outer groove of the arm half way down. The mass of the biceps ends in a wedge which turns outward as it enters the cubital fossa.

The mass of the forearm overlaps the end of the arm on the outside by a wedge (supinator longus) that arises a third of the way up the arm, reaches a broad apex at the broadest part of the forearm and tapers to the wrist, pointing always to the thumb; and on the inside by a wedge that rises back of the arm and points to the little finger (flexor-pronator muscles).

In the lower half of the forearm, the thin edge of the mass, toward the thumb, is made by a continuation of this wedge from the outside; while the thin edge toward the little finger is made by the end of the wedge from the inside.

When the elbow is straight and the hand turned in, the inner line of the forearm is straight with that of the arm. When the hand is turned out, this line is set out at an angle that corresponds with the width of the wrist. The little finger side (ulna) being the hub of its movement.

The flexor tendons on the front of the forearm point always to the inner condyle; the extensor tendons on the back point always to the outer condyle.

The breadth of the hand corresponds with that of the lower mass; not joining it directly, but with a step-down toward the front.

In the back view of the arm, the mass of the shoulder sits across its top as in the front view. The back edge of this mass is seen to be a truncated wedge arising under the deltoid and focusing on the elbow. The upper end resolves itself into the three heads of the triceps; the lower or truncated end is the triceps tendon, to which is to be added the tiny wedge of the anconeus (donkey's foot) muscle bridging from outer condyle to ulna.

The Armpit

❖

The hollow of the arm, filled with its friction hairs, is made into a deep pit by the great breast muscle (pectoralis major) in front, and the greater latissimus dorsi behind.

Its floor slopes forward, downward and outward, following the slope of the chest wall.

Its rear wall is deeper, since the latissimus attaches farther down the back; thicker because made of two muscles (latissimus and teres major), and rounder because its fibres turn on themselves before attaching to the arm bone.

The front wall is longer because the pectoral muscle attaches farther down the arm.

Into this pit the biceps and triceps muscles plunge, with the coraco-brachialis between them.

The bottom of the pit may, when the arm is fully raised, be bulged by the head of the arm bone and the lymph glands that lie there.

THE SHOULDER

MECHANISM OF THE ARMPIT, front view:

1 Biceps.

2 Triceps.

3 Latissimus dorsi.

4 Teres major.

5 Deltoid.

Latissimus Dorsi: From spine, sixth dorsal to sacrum and iliac crest; passes inside of humerus to fasten to front side near head.

Action: Draws arm backward and inward.

Teres Major: From lower corner of scapula to front of humerus.

Action: Draws humerus outward and rotates backwards.

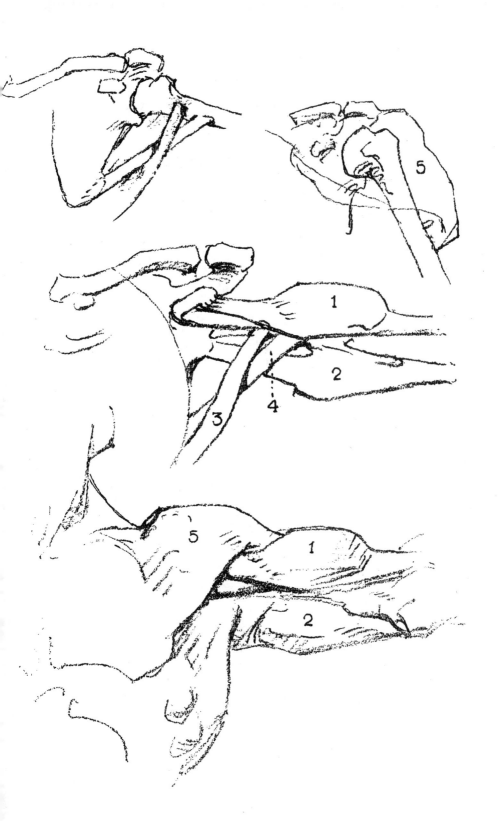

THE ARM

WEDGING AND INTERLOCKING OF THE MASSES OF THE ARM AND SHOULDER

(See Masses, page 63)

THE SHOULDER

1 Deltoid.

2 Triceps.

3 Teres minor.

4 Teres major.

Deltoid: From clavicle, acromion and ridge of scapula to outside of humerus.
Action: Elevates, draws forward or backward, humerus.

Triceps: Outer head, back of humerus above musculo-spiral groove. Inner head, back of humerus below musculo-spiral groove. Middle or long head, shoulder blade below socket to olecranon process of ulna.
Action: Extends forearm.

Teres Minor: From scapula to inner tubercle of humerus.
Action: Draws humerus outward and rotates backward.

Teres Major: From lower corner of scapula to front of humerus.
Action: Draws humerus outward and rotates backwards.

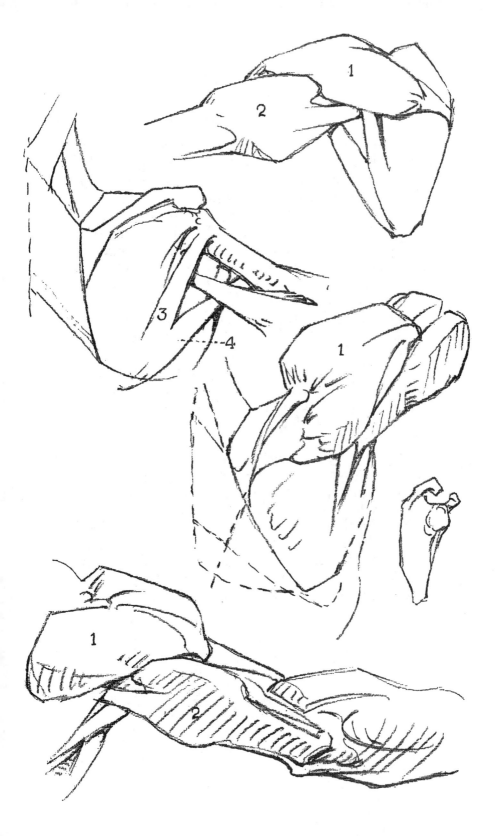

The Neck

❀

From the sloping platform of the shoulders the neck rises, a cylindrical column, curving slightly forward even when the head is thrown well back.

It is canopied in front by the chin. It is buttressed on the sides by the trapezius (table) muscle. The table shape of this muscle appears only from the back, a diamond with lower apex well down the back. Its lateral corners arise from the shoulder girdle opposite the deltoid. Rising diagonally upward it braces the back of the head.

The strength of the neck is therefore at the back, which is somewhat flat and overhung by the base of the skull.

From bony prominences back of the ears two muscles (sterno-mastoid), aptly called the bonnet-string muscles, descend to almost meet at the root of the neck, forming a triangle whose base is the canopy of the chin.

In this triangle below is the thyroid gland, larger in women; and above it the angular cartilage of the larynx, or Adam's apple, larger in men.

Crossing its upper corners outward and downward is a thready skin muscle (platysma myoides) which lifts the skin into high folds and draws down the corners of the mouth. It carries the imagination back to the time in evolution when bared teeth were important weapons of defense.

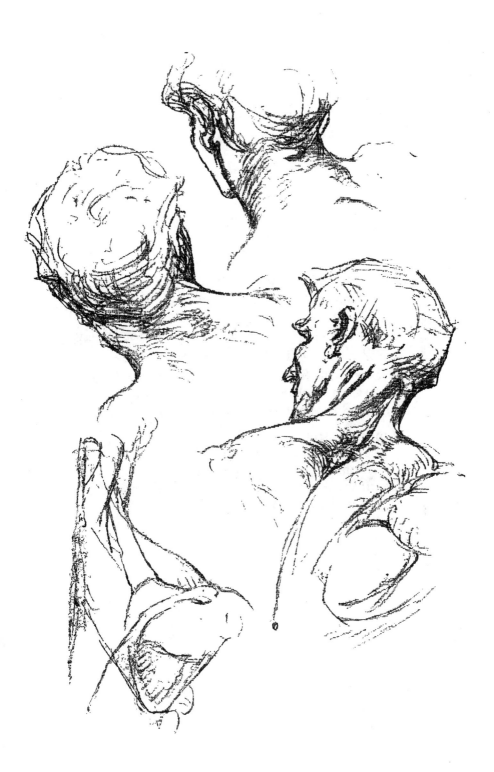

THE NECK

MUSCLES OF THE NECK:

1 Sterno-cleido-mastoid.

2 Levator of the scapula.

3 Trapezius.

Sterno-cleido-mastoideus: From top of sternum and sternal end of clavicle to mastoid process (back of ear).

Action: Together, pull head forward; separately, rotates to opposite side, depresses head.

Levator of the Scapula: From upper cervical vertebræ to upper angle of shoulder blade.

Action: Raises angle of shoulder blade.

Trapezius: From occipital bone, nape ligament and spine as far as twelfth dorsal, to clavicle, acromion and ridge of shoulder blade.

Action: Extends head, elevates shoulder and rotates shoulder blade.

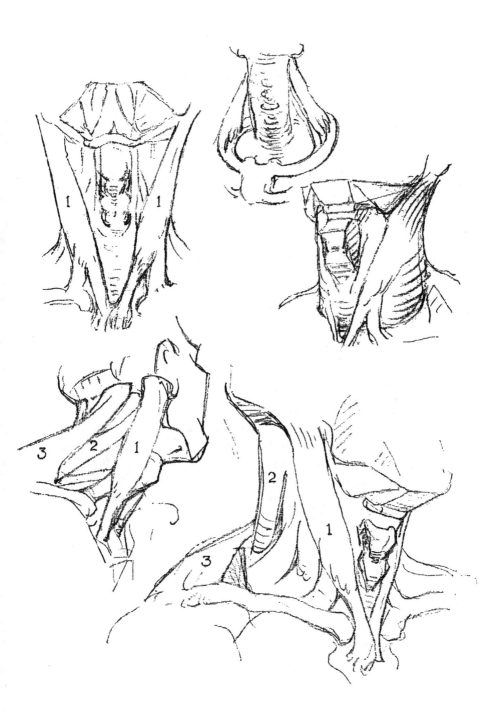

THE NECK

1 Hyoid bone.

2 Thyroid cartilage.

3 Thyroid gland muscles.

4 Digastric (has two portions).

5 Stylo-hyoid.

6 Sterno-hyoid.

7 Omo-hyoid.

8 Sterno-cleido-mastoid.

9 Trapezius.

MOVEMENTS OF THE NECK

In the neck are seven vertebræ, each moving a little. When the neck is turned to one side, that side of each vertebra moves back as far as the perpendicular and then the opposite sides move forward, lengthening the neck as they do so. This motion is much freer at the second joint from the skull, which turns on a pivot. The joint of the skull itself moves only in nodding, in which the rest of the neck may be quite stationary.

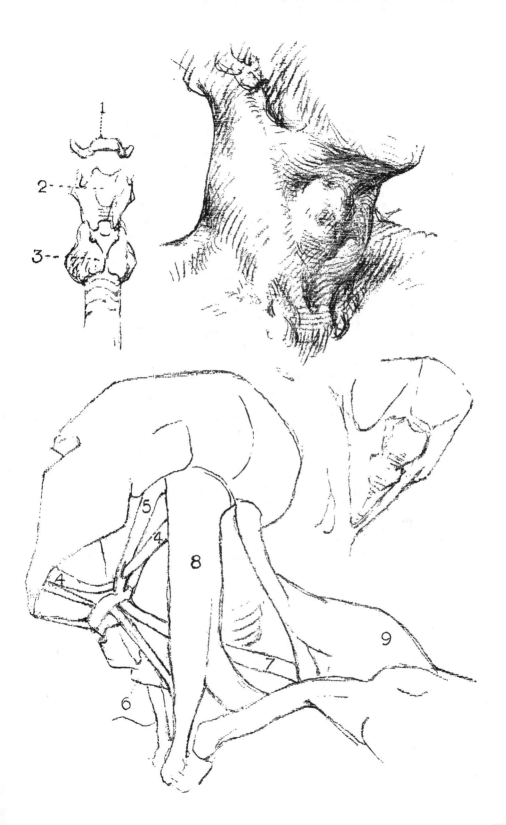

THE NECK

Muscles of Neck

Platysma Myoides: A sheathing from chest and shoulder to masseter and corner of mouth.
Action: Wrinkles skin of neck, draws down corner of mouth.

Digastric (double-bellied muscle): Anterior belly, from maxilla, behind chin; posterior belly, from mastoid process; fastened by loop to hyoid bone.
Action: Raises hyoid and tongue.

Mylo-hyoid: Forms floor of mouth and canopy of chin in front.
Stylo-hyoid: From hyoid to styloid process.
Action: Draws back hyoid and tongue.

Sterno-hyoid: From sternum to hyoid bone.
Action: Depresses hyoid and Adam's apple.

Omo-hyoid: From hyoid bone to shoulder, upper border of scapula.
Action: Draws hyoid down and to one side.

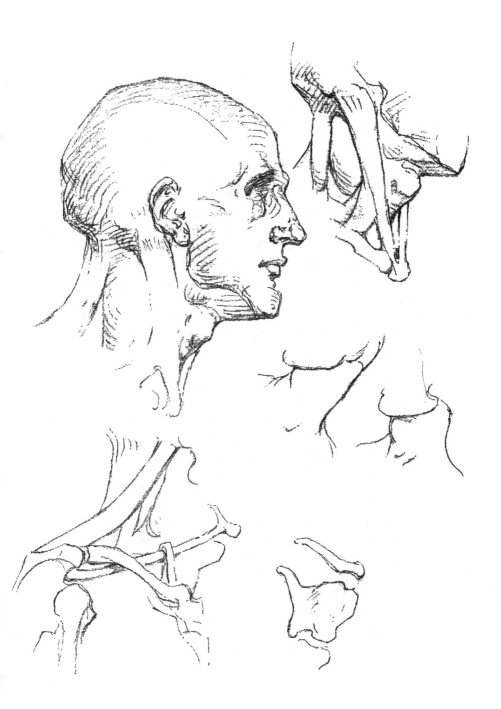

The Head

❁

For so long a time has the oval been used as the basis for the construction of the human head and face that the use of the block or cube seems quite revolutionary.

Yet for many reasons the cube seems preferable. The oval is too indefinite, and offers no points for comparison, no basis for measurement. The eye does not fix on any point in a curved line.

On the ground plan of a square, however, any form may be built. The block moreover carries with it from any angle its perspective and its fore-shortening, and it carries with itself the sense of *mass*.

Especially does it carry with itself the important element of the bilateral symmetry of the head—a symmetry that is present indeed in all living things. A vertical line in the centre divides the head or the trunk into parts equal, opposite, and complemental. The right eye is the counterpart of the left; the two halves of the nose are symmetrical; the limbs, except for changes of position, are exact though reversed duplicates of each other.

How to construct such a block?

Camper, Professor Bell, and others have studied innumerable human skulls trying to discover some constant measurement by which to classify them as ancient or modern or according to race. They finally fixed upon two lines with the angle between them. The first passes from the base of the nose to the roof of the ear canal; the second passes from the upper incisor teeth to the prominent part of the forehead.

The angle between these lines is practically con-

stant for a given race or a given age of evolution. Individual variations occur, but they are less than the standard.

This angle is less in the older and less evolved races, and the vertical line approaches nearer the perpendicular in the newer races, especially the Caucasian. In the classical Greek head it even passes the perpendicular, although no actual Greek skulls in which this is the case have ever been discovered.

This angle, in the Caucasian races, is about eighty degrees. It is not easy to construct a block on such an angle, and it is very desirable to have a right angle. By dropping the horizontal line at its rear end from the roof of the ear canal to the tip of the ear lobe, and by drawing the vertical line from the base of the nose where it joins the upper lip to the bridge of the nose, where it joins the glabella, we obtain such a right angle.

If on these straight lines a cage be built, bounding the head and face, it will be found that the front and back are oblong and the sides are square.

The top of the cage should be level with the top of the head, the bottom with the bottom of the chin; the border of the cheek should fit the sides. The length of the oblong front will equal one and three-quarters times its width. The cheek bones set back from the front of the cage about one-third of the distance to the ear.

BLOCKED
CONSTRUCTION OF THE HEAD

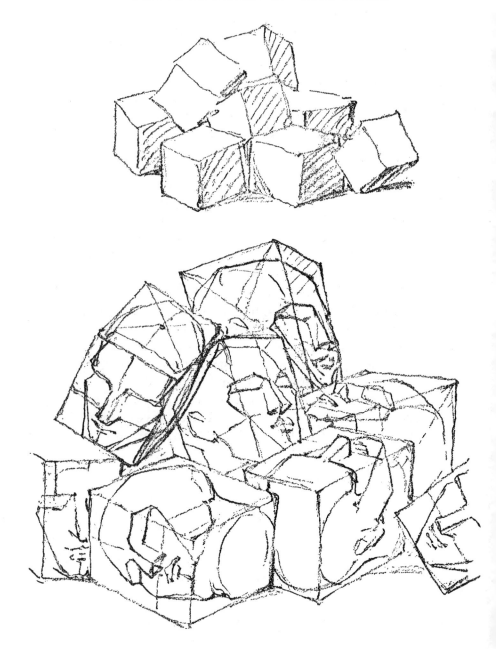

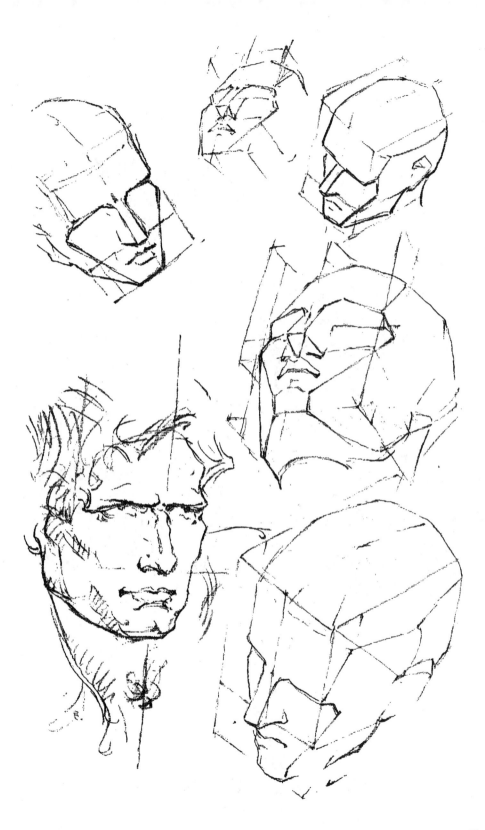

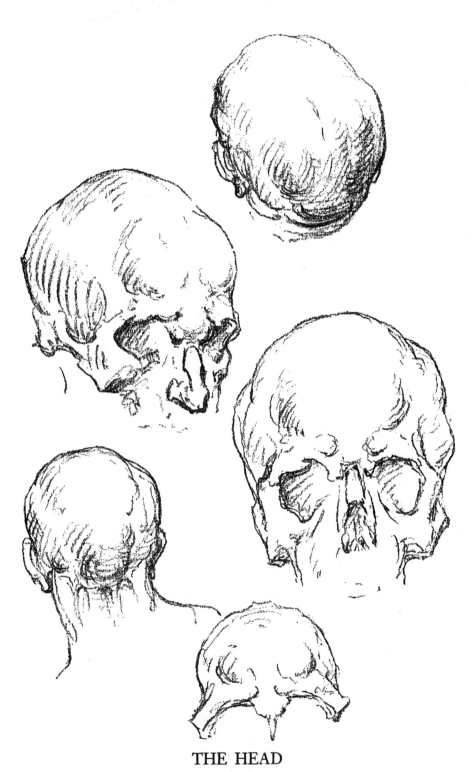

THE HEAD

Eminences, Ridges and Depressions
of the Skull

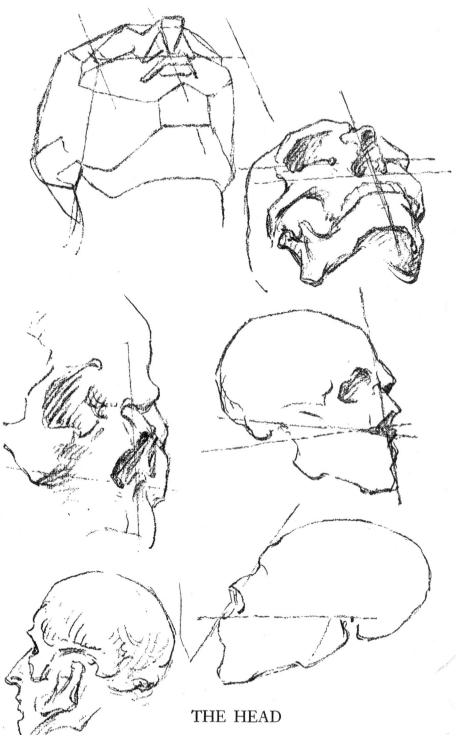

THE HEAD

THE ANGLES OF CONSTRUCTION

Text Page 80

THE HEAD

1 Temporal.

2 Masseter.

3 Buccinator (cheek muscle).

4 and 5. Lesser and greater zygomaticus (muscles of expression).

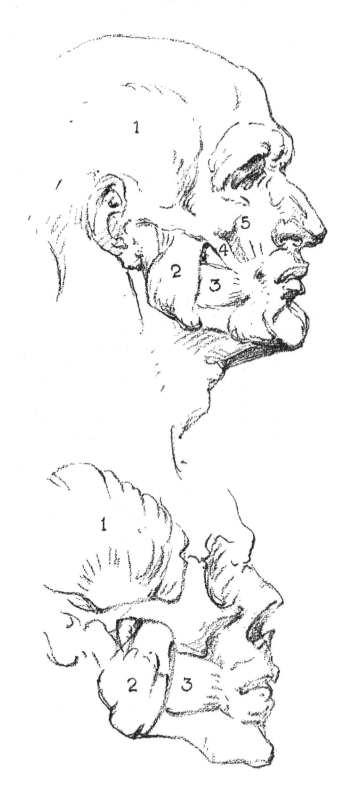

THE HEAD

MASSES

The masses of the head are the cranium, the skeleton of the face, and the jaw.

Into the rounded mass of the cranium sets the narrower mass of the forehead bounded by the temples at the sides and by the brows below.

From the lower outer corners of the forehead the wedge of the cheek bones begins; moves outward and downward until it just passes the curve of the cranium, then down and in, in a long sweep, to the corner of the chin.

Outside of and behind this lower line is another wedge, that of the corner of the jaw, with the line itself for base, and a very low apex.

The two cheek bones form together the central mass of the face, in the middle of which rises the nose.

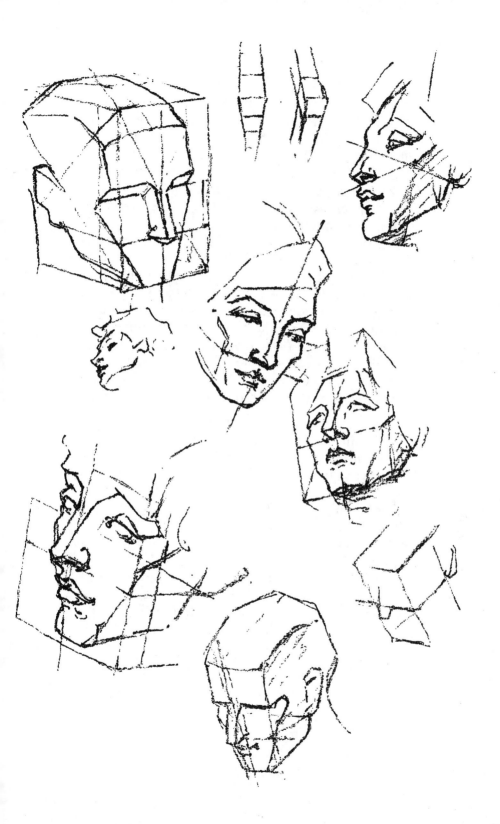

THE HEAD

PLANES

The plane of the forehead slopes upward and backward to become the cranium; and the sides turn sharply to the plane of the temples.

The plane of the face, divided by the nose, is broken on each side by a line from the outer corner of the cheek bone to the center of the upper lip, making two smaller planes.

The outer of these turns to become the plane of the jaw, which also is again divided by a line marking the edge of the masseter muscle, running from the outer border of the cheek bone to the corner of the jaw; and again making two secondary planes, one toward the cheek and one toward the ear.

The relations of these masses and planes is to the moulding of a head what architecture is to a house. They vary in proportion with each individual, and must be carefully compared with a mental standard.

THE HEAD—PROFILE

In profile the masses of the head are the same— the cranium, the skeleton of the face, and the jaw.

The front border of the temple is seen to be a long curve, almost parallel to the curve of the cranium.

The top of the cheek bone is seen to be prolonged backward toward the ear as a ridge (zygoma or yoke) which also marks the base of the temple. It slopes slightly down in front.

From cheek bone and zygoma, where they meet, a lesser ridge is seen rising between the temple and the orbit, marking the back of the orbit and the first part of the long line of the temple.

PLANES

The planes and divisions of planes of the face are the same as in the front view, in different perspective.

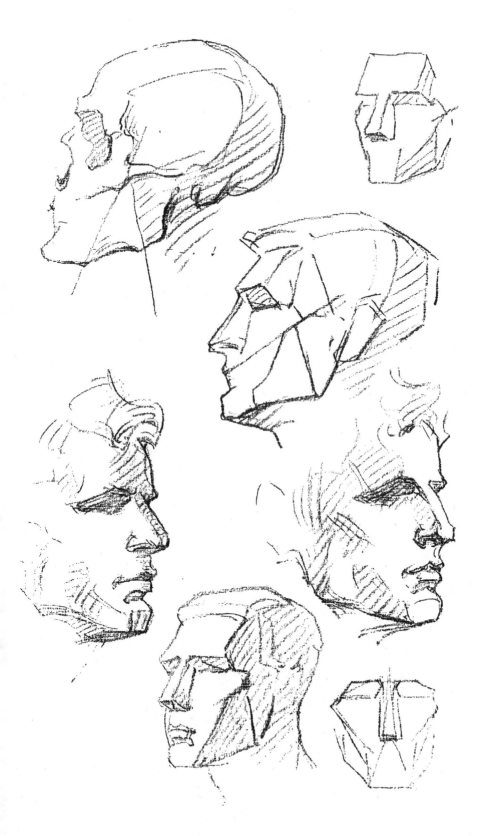

THE HEAD

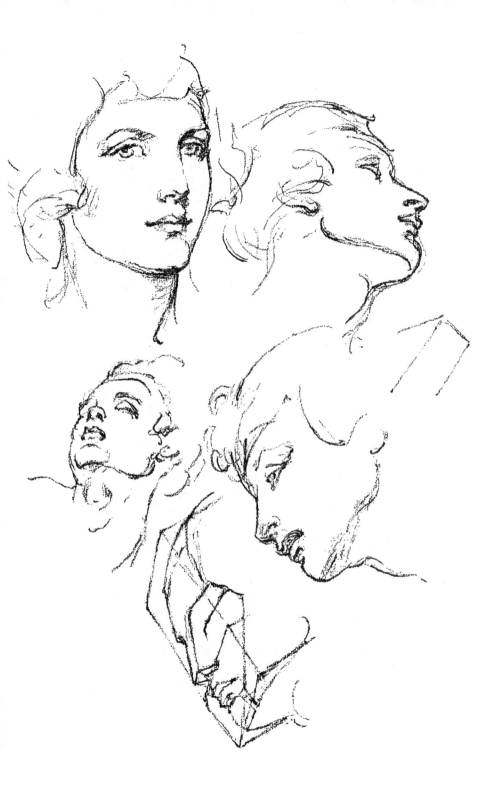

93

The Eye

❀

The upper part of the eye socket or orbit is marked by the brow, whose bristles are so placed as to divert moisture and dirt outward away from the lid and eye.

Below it on the lid are three planes, wedging into each other at different angles. The first is from the bridge of the nose to the eye. The second is from the brow to the cheek bone; which is again divided into two smaller planes, one sloping toward the root of the nose, the other directed toward and joining with the cheek bone.

The lower lid is quite stable. It is the upper lid that moves. When the eye is closed, its curtain is drawn smooth; when opened, its lower part follows the curve of the eyeball straight back, folding in beneath the upper part as it does so, and leaving a wrinkle to mark the fold.

The lower lid may be wrinkled and slightly lifted inward, bulging below the inner end of the lid.

The transparent cornea or "apple" of the eye is raised perceptibly, and is always curtained by the upper lid, in part, so that it always makes a slight bulge in the lid, whatever the position, and whether open or closed. The eyeball has about half a right angle of movement in two planes.

At the inner corner of the lids is a narrow pit (canthus), floored by a pinkish membrane, which projects some distance beyond the walls of the pit when the eye is turned far out. At the corners of the pit are the openings of the tear ducts, which drain off the excess of lacrymal (tear) fluid. There is a continuous light secretion of this fluid, which

is spread over the eyeball by the constant winking of the upper lid. The thin film of liquid thus kept there reflects light perfectly from its surface.

The lashes, projecting from the margin of the lids, serve both as curtains to shade and as delicate feelers to protect the eye.

The immovable masses of the forehead, nose and cheek bones form a strong setting for this most variant and expressive of the features.

COMPARISONS

In looking at any feature one naturally compares it with his concept of the average of such features, or with some mental standard or ideal.

The variations of such features will then fall into classes which represent the more usual variations thereof.

Eyebrows may be level or sloping; straight or arched; short or long; narrow or wide, thick, scanty or penciled.

Lids may be thick or thin, although the upper lid is always thicker along its margin, and always protrudes if the eye protrudes, and is raised over the cornea.

Eye sockets may be far apart or near together; long or short; bulging or shallow.

The opening between the lids may be triangular or round, a loop, or a button hole.

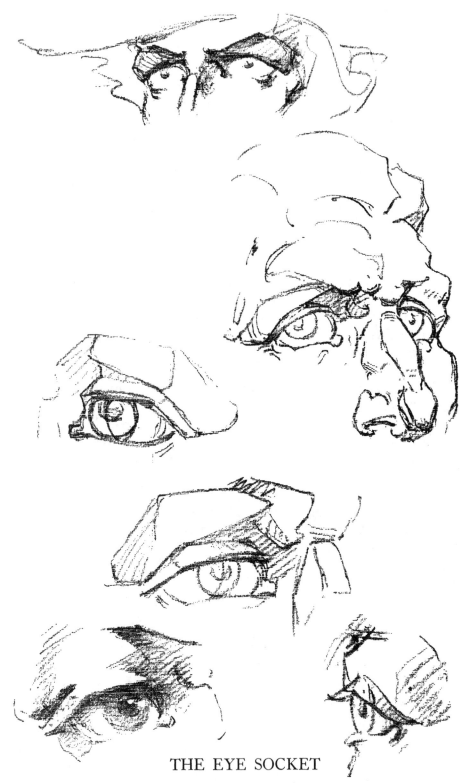

THE EYE SOCKET

Wedges, Planes and Their Angles

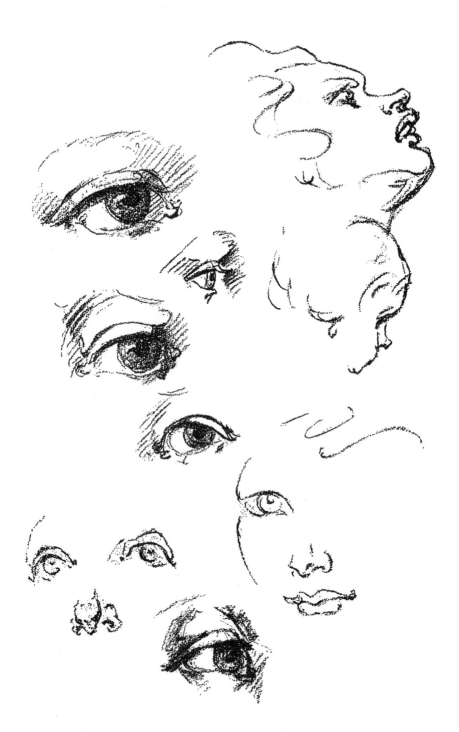

THE EYE

THE EYE

Angular Opening Between the Lids

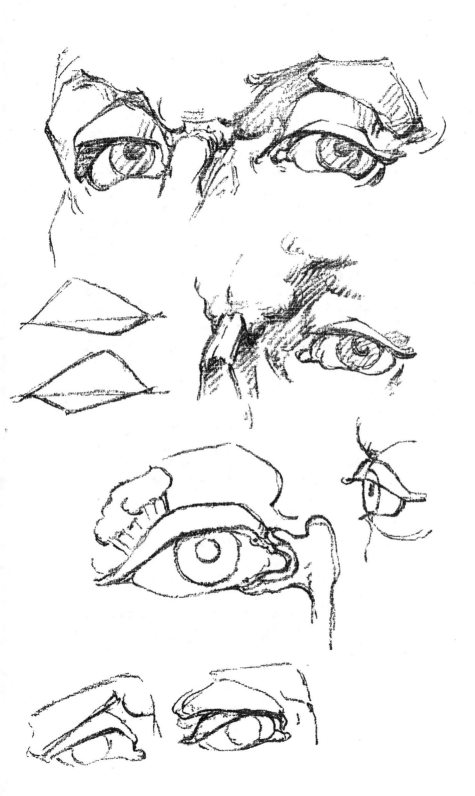

99

The Nose

❀

The nose is made of a series of wedges based on its bony structure.

Where the bridge of the nose wedges in under the forehead, the two ridges of the glabella descend to form a wedge with apex at the bridge.

The bony part of the nose is a very clear wedge, its ridge only half the length of the nose, higher as it descends; its base somewhat longer, wider as it descends, making the second wedge.

Beyond the bony part, the nose narrows and the ridge sinks slightly toward the bulb, making a third wedge, base to base with the second.

The bulb rises as two sheets of cartilage from the middle of the upper lip (septum of the nose), expands into the bulbous tip, flows over the sides, and flares out to form the alæ or wings of the nostrils.

This cartilaginous portion is quite movable. The wings are raised in laughter, dilated in heavy breathing, narrowed in distaste, and wings and tip are raised in scorn, wrinkling the skin over the nose.

COMPARISONS

Average variations in noses divide them into classes.

They may be small, large, or very large; concave or convex; humped, Roman or straight.

At the tips they may be elevated, horizontal, or depressed; flattened, tapering or twisted.

The wings may be delicate or puffy, round or flat, triangular, square or almond-shaped.

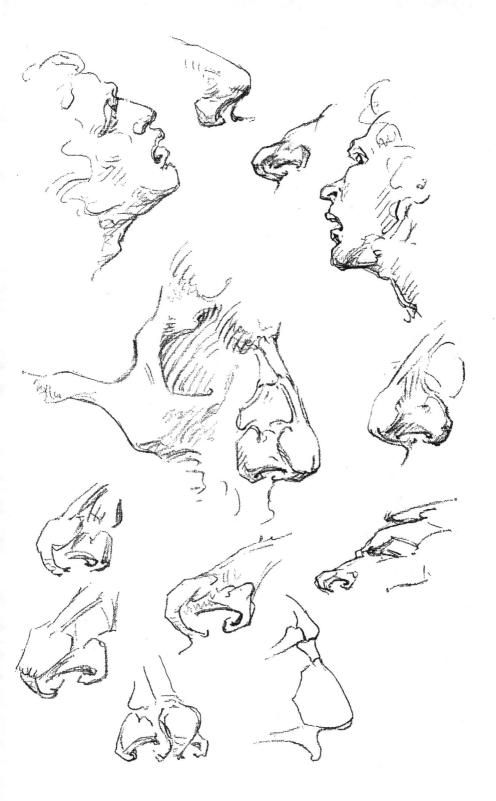

THE NOSE

Cartilages of the Nose:

1 Upper lateral.

2 Lower lateral.

3 Wing.

4 Septum.

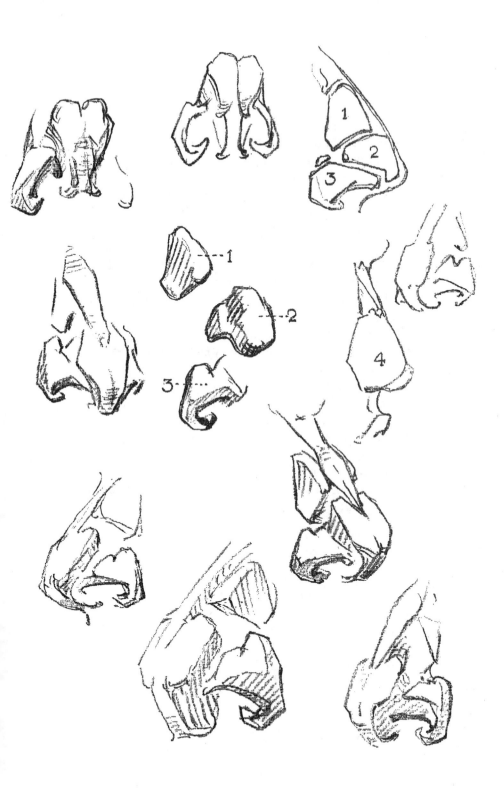

1

2

3

1

2

3

4

The Ear

❁

In animals, the external ear is a smooth cornucopia of cartilage, freely movable, ending in a point.

In man it is practically immobile, and its muscles, now mere elastic bands, serve only to draw it into wrinkles. These vary widely, but there are certain definite forms: an outer rim (helix) bearing the remains of the tip; an inner elevation (anti-helix), in front of which is the hollow of the ear (concha) with the opening of the canal, overhung in front by a flap (tragus) and behind and below by a smaller one (anti-tragus). To the whole is appended a lobe.

The ear is vertically in line with the back of the jaw, and lies horizontally between the lines of the brow and the base of the nose.

In it three planes are to be found, divided by lines radiating from the canal, up and back and down and back. The first line marks a depressed angle between its planes, the second a raised angle.

Average variations in ears present the following classes: large, medium or small; round, oval or triangular. The remains of the point of the ear may be marked or absent.

CARTILAGE OF THE EAR

1 Helix.

2 Anti-helix.

3 Tragus.

4 Anti-tragus.

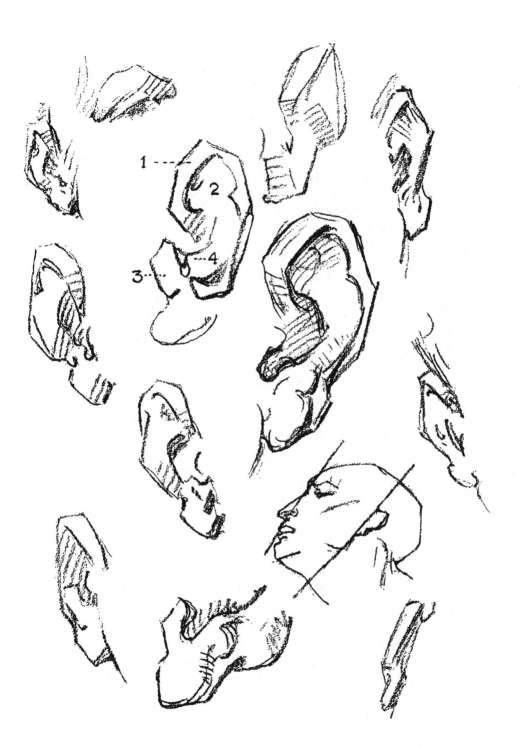

105

The Mouth

❀

The shape of the mouth and lips is controlled by the shape of the jaw. The more curved the jaw in front the more curved the lips; the more flat it is, the straighter the lips. A much bowed mouth does not occur on a jaw bone that is flat in front, nor a straight slit of a mouth on a curved set of upper teeth.

The curtainous portion of the mouth (from nose to margin of red lip) presents a central groove with pillars on either side, blending into two broad drooping wings, whose terminus is at the pillars of the mouth. The groove ends in a wedge entering the upper lip (red portion). This portion is set at an angle with the curtainous portion.

The upper and lower red lips, accurately adapted to each other when closed, are yet quite different in form; the upper being flat and angular, the lower rounded.

The upper red lip has a central wedge-shaped body, indented at the top by the wedge of the groove above, and two long slender wings disappearing under the pillars of the mouth.

The lower red lip has a central groove and two lateral lobes. It has three surfaces, the largest depressed in the middle, at the groove, and two smaller ones on each side, diminishing in thickness as they curve outward, not so long as the upper lip.

The base or curtainous portion of the lower lip sets at an angle with the red portion less than that in the upper lip. It slopes backward and ends at the cleft of the chin. It has a small linear central

ridge and two large lateral lobes, bounded by the pillars of the mouth.

The oval cavity of the mouth is surrounded by a circular muscle (orbicularis oris) whose fibres, overlapping at the corners, raise the skin into the folds known as the pillars of the mouth.

Its outer margin is usually marked by a crease in the skin running from the wings of the nose out and down to varying distances, paralleling the pillars. Its lower end may blend into the cleft of the chin. From this muscle radiate various facial muscles of expression.

Average variations in lips present the following comparisons: thick or thin; prominent, protruding or receding; and each may be compared with the other in these respects: straight, curved or bowed, rosebud, pouting or compressed.

The Chin

❖

Below the cleft of the chin, the chin itself protrudes. Its breadth at the base is marked by two lines which, prolonged, would meet at the septum of the nose, making a triangle that wedges upward into the base of the lower lip. It is bordered on each side by two planes which reach to the angle of the jaw.

Variations in chins present the following comparisons: high or low; pointed or ball; flat, furrowed or dimpled; elongated, double, etc.

THE MOUTH
DETAILS OF MOUTH AND LIPS

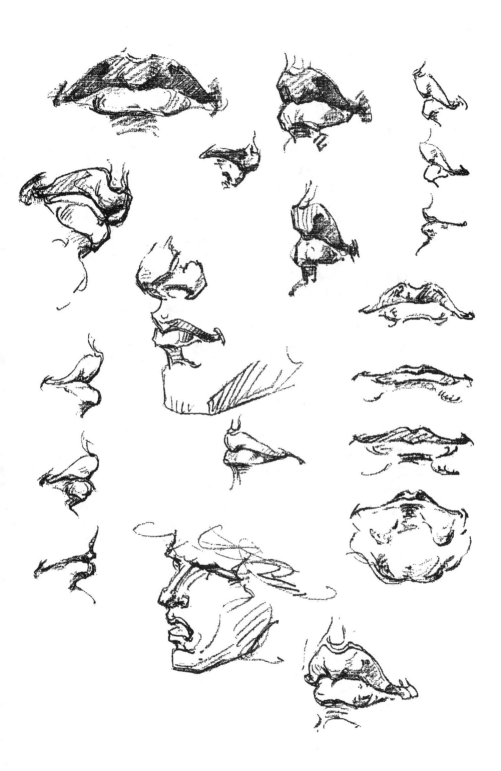

The Trunk—*front view*

❀

ANATOMY

The upper part of the body is built around a bony cage called the thorax, conical in shape, and flattened in front. The walls of this cage are the ribs, twelve on each side, fastening to the spine behind and to the sternum or breast bone in front. The upper ribs are quite short and make a small circle; they grow longer until the seventh, which is the longest and the last to fasten to the breast bone. The next three grow shorter and shorter, and reach the sternum only through a long costal cartilage, which with the projecting end of the sternum (ensiform cartilage) form the abdominal arch. The last two ribs are quite short and are free at their front ends. The first seven are called true ribs, the next three false, and the last two floating ribs.

COLLAR BONE

To the breast bone at the top of this cone the collar bones are attached, lifting the whole mass away from the cone and making it a flat surface, wedging downward. The inner ends of the S-shaped bone are curved around the apex of the cone, but the outer ends move forward again, bringing the mass of the shoulders with them to form the flat front surface.

MUSCLES

Thus, without the shoulders, the cage of the chest is a cone with the apex upward. Under the muscles this form may easily be seen.

With the shoulders, it is a wedge with the apex downward. The profile of the sides forms a wide wedge, buttressed by a mass of lateral muscles over the iliac crest.

The front surface, formed mainly by the pectoral and rectus abdominis muscles, forms a much more slender wedge. Its upper third bevels more sharply in, as far as the lower border of the breast muscle, paralleling the edge of that muscle, bounded by a line across the bottom of the breast muscle, just below the nipple, through the epigastric pit. Its lower two-thirds bevels more sharply down, following the edge of the rectus muscle; its lines almost meet at the symphysis pubis below.

A vertical central groove divides the symmetrical halves of the front, running its full length. It begins in the pit of the neck, between the collar bones. Over the breast it marks the breast bone, and is deepened by the bulge of the pectoral muscles on either side. At the end of this, its upper third, is a pit (epigastric pit) marking the divergence of the ribs.

At the end of its middle third is another pit, the umbilicus or navel. At the end of its lower third is the mound of the symphysis. This line is useful for placing the masses of the chest, the epigastrium (over the stomach) and the abdomen.

MASSES

The masses of the torse are the chest, the abdomen or pelvis, and between them the epigastrium; the first two comparatively stable, the middle one quite movable.

A straight line marking the collar bones defines the top of the first mass; and paralleling it, a line through the base of the breast muscles and pit of the epigastrium forms its base.

Although the shoulders are freely movable, changing the lines of the first mass, and bulging the pectoral muscles, yet the mass itself changes little except the slight change in respiration. Even in respiration the upper portion, as far as the level of the epigastric pit, changes little; the lower ribs perform most of the respiratory movement.

Centering on this pit is the abdominal arch, made of the cartilages of the false ribs. At its centre, the end of the breast bone (ensiform cartilage) hangs pendent; on either side the arch descends diagonally, variously curved, separating thorax from abdomen.

Below this arch is the abdomen, the most movable part of the mobile portion. It is bounded below by a line passing approximately through the anterior points of the iliac crests. Its profile shows the lines of the cone of the thorax diverging downward, the lines of the wedge of the chest and shoulders converging downward, and the buttressing of the lateral muscles.

In the bending or turning of the body the central line of this portion bends always to the convex side, always paralleled by the borders of the rectus muscle.

By this movement the straight wedge of the front is broken. It becomes not a bent wedge, but two wedges; one the upper half of the original wedge, prolonged but not completed downward; the other the lower half, prolonged upward to meet the one above.

More unchanging than either of the above is the mass of the abdomen. The central groove is here shallow and may lose itself below. The long wedge ends in the symphysis pubis.

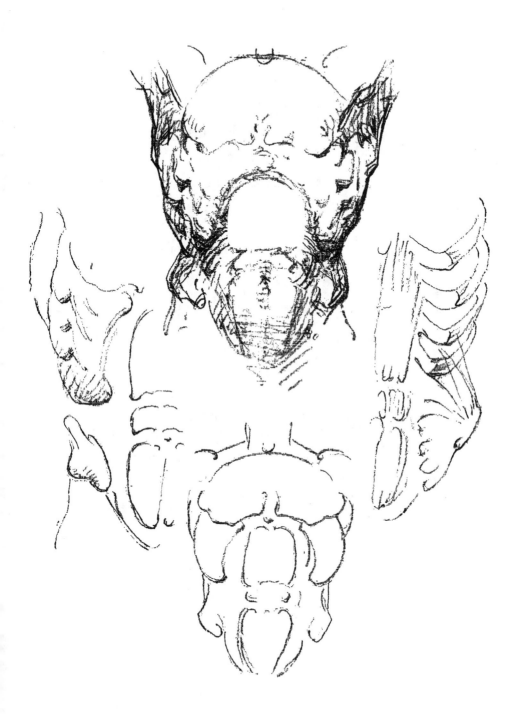

THE TRUNK

Muscles of the Trunk, front view:

1 Pectoralis major.

2 Deltoid.

3 Rectus abdominis.

4 Serratus magnus.

5 External oblique.

Pectoralis major, page 116

Deltoid, page 70.

Rectus Abdominis: From symphysis pubis to cartilages of ribs, from fifth to seventh.
Action: Flexes thorax.

Serratus Magnus: From eight upper ribs to scapula—spinal edge, under surface.
Action: Draws shoulder blade forward, raises ribs.

External Oblique: From eight lower ribs to iliac crest and ligament to pubis.
Action: Flexes thorax.

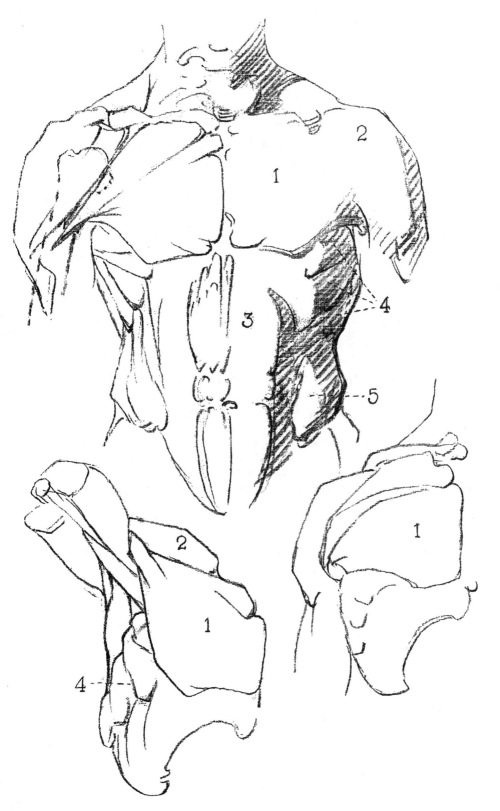

SKELETON OF THE TRUNK

Muscles Covering Upper Portion, front view:

1 Pectoralis minor.

2 Pectoralis major.

Pectoralis Minor: From third, fourth and fifth ribs to coracoid process.
Action: Depresses point of shoulder.

Pectoralis Major: From inner half of clavicle, sternum, costal cartilages as far as sixth and seventh ribs to humerus.
Action: Draws arm downward and forward.

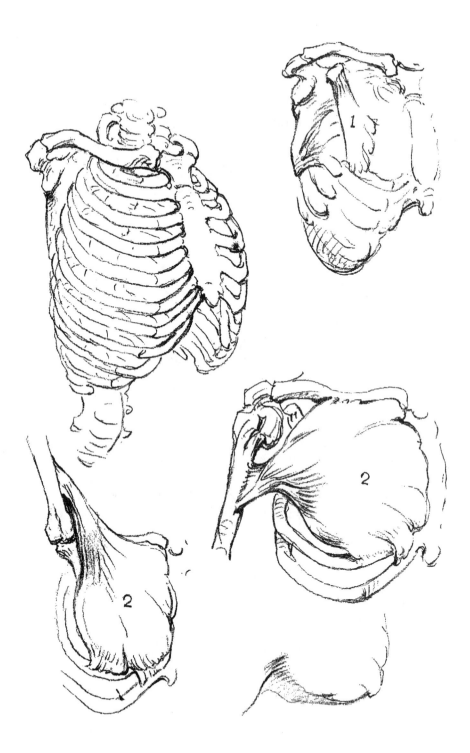

THE TRUNK
TRUNK, front view
ARMPIT AND SHOULDER

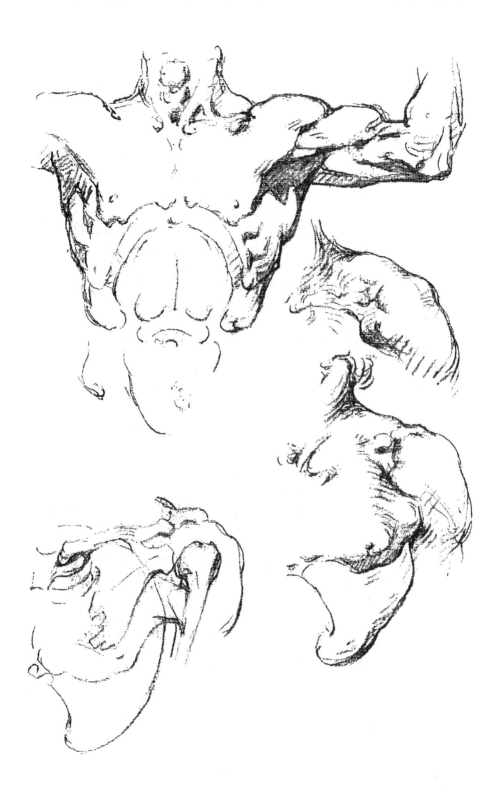

The Torse

❀

The erect torse presents in profile the long curve of the front, broken by depressions at the border of the breast muscle and at the umbilicus or navel into three lesser curves, almost equal in length. The back presents the sharp anterior curve of the waist, opposite the umbilicus, bending into the long posterior curve of the chest, and the shorter curve of the buttocks. The former, that of the chest, is broken by the almost vertical shoulder blade and the slight bulge of the latissimus below it.

In profile the torse presents three masses: that of the chest, that of the waist, and that of the pelvis and abdomen. The first and last are comparatively unchanging.

Above, the mass of the chest is bounded by the line of the collar bones; below, by a line following the cartilages of the ribs, being perpendicular to the long diameter of the chest.

This mass is widened by the expansion of the chest in breathing, and the shoulder moves freely over it, carrying the shoulder blade, collar bone, and muscles.

It is marked by the ridge of costal cartilages that forms its border, sloping up and forward, and by the ribs themselves, sloping down and forward, and by the "digitations" (finger marks) of the serratus magnus (big saw-toothed) muscle, little triangles in a row from the corner of the breast muscle, paralleling the cartilages of the ribs, disappearing under the latissimus.

Below, the mass of the pelvis and abdomen slopes up and forward. It is marked by the iliac crest and hip, described later. In front it may be flattened by contraction of the abdominal muscles. Over its surface the hip moves freely, changing the tilt of the pelvis.

Between these the central mass contains the waist vertebræ, and is very changeable. Practically all of the movement of flexion and extension for the whole spine occurs here, and much of the side-bending.

This mass is marked by a buttress of lateral muscles, slightly overhanging the pelvic brim and bearing inward against the side above. It changes greatly in different positions of the trunk.

TORSE—BACK VIEW

The back presents numerous depressions and prominences. This is due not only to its bony structure, but to the crossing and recrossing of a number of thin layers of muscles. It should be borne in mind that the superficial or outside layers manifest themselves only when in action. For this reason, under all changes of position, the spine, the shoulder-blade with its acromion process, and the crest of the ilium, must be regarded as the landmarks of this region.

The spine is composed of twenty-four vertebræ. It extends the full length of the back, and its course is marked by a furrow. The vertebræ are known as the cervical, dorsal and lumbar. The cervical vertebræ are seven in number, and the seventh is the most prominent in the whole of the spine. It is known as vertebra prominens. In the dorsal region the furrow is not so deep as below. Here there are twelve vertebræ. When the body is bent forward,

the processes of the vertebræ in this section are plainly indicated.

The spinal furrow becomes deeper as it reaches the lumbar vertebræ, where it is marked by dimples and depressions. It widens out, too, in this part of the body, and as it passes over the surface of the sacrum to the coccyx it becomes flattened. The average length of the spine is about two feet three inches.

The outer corner of the shoulder girdle is the acromion process, which is the high outer extremity of a ridge rising from the shoulder blade. The shoulder blade or scapula (spade) is a flat plaque of bone fitting snugly against the cage of the thorax, having a long inner vertical edge, parallel to the spine; a sharp lower point; a long outer edge pointing to the arm pit; and a short upper edge parallel with the slope of the shoulder. The ridge, or spine of the scapula, starts at the spinal edge, about a third of the way down, in a triangular thickening, and rises until it passes high over the outer upper corner, where the shoulder joint ties, then turns forward to join with the collar bone at the acromion. The prominent portions are this ridge and the spinal edge and the lower corner. The upper outer corner is thickened to form the socket for the head of the humerus, forming the shoulder joint proper.

MOVEMENTS

Movement of flexion and extension occurs almost entirely in the waist or lumbar vertebræ. Movement of side-bending occurs throughout the whole length. Movement of rotation occurs in the lumbar vertebræ when the spine is erect, in the middle vertebræ when it is half flexed, in the upper vertebræ when the spine is fully bent. In the lum-

bar vertebræ, the axis of this rotation is *behind* the spine; in the middle vertebræ it is neutral; in the upper dorsals it is in front of the spine.

Each vertebra moves a little, and the whole movement is the aggregate of the many little movements.

The shoulder blade slides against the surface of the cage of the thorax, in any direction, and may be lifted from it so that its point or its spinal edge become prominent under the skin. It produces easily fifty per cent. of the whole movement of the shoulder.

MASSES AND MARKINGS

From the rear the mass of the torse presents a great wedge, with apex downward, marked by a complex of lesser wedges and diamonds, and the shoulder blades.

The profile of the sides presents a wide incomplete wedge, whose lines if prolonged would form an apex well below the buttocks. The surface proper of the back presents a great wedge, with base at the corners of the shoulders, with apex driven between the buttocks, buttressed on the sides by the lateral masses of waist muscle. With the addition of the neck, this becomes a diamond with a very blunt top.

From end to end vertically runs the dividing line of the spine; when bent, a series of knobs (tips of vertebral spines); when erect a groove except at the root of the neck, the spine of the seventh cervical vertebra. This serves as a sort of ridge pole for muscular tendons for neck and shoulders; and around it therefore is a flat unbroken fascia without muscular fibres, forming a lesser diamond nestling below the upper apex.

THE TRUNK

THE TRUNK, side view:

1 Latissimus dorsi.

2 External oblique.

Latissimus dorsi: From spine, sixth dorsal, to
sacrum and iliac crest; passes inside of humerus
to fasten to front side near head.
Action: Draws arm backward and inward.

External Oblique: From eight lower ribs to iliac
crest and ligament to pubis.
Action: Flexes thorax.

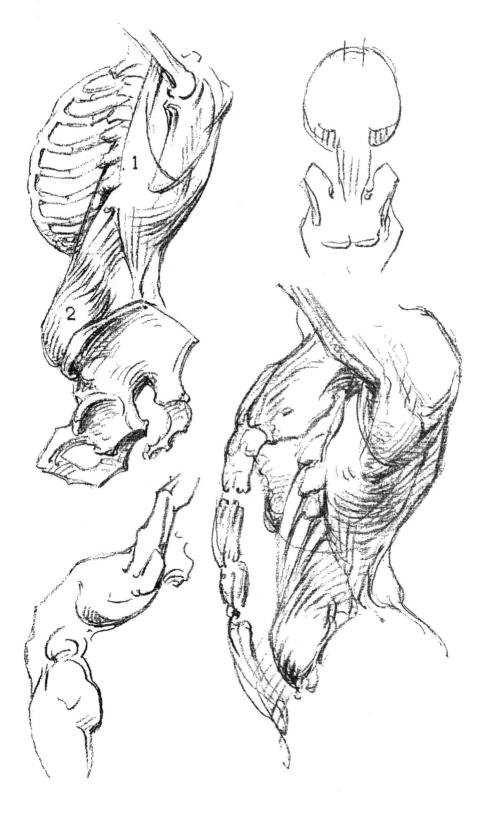

1

2

THE TRUNK

Muscles of the Trunk, back view:

1 Trapezius.

2 Deltoid.

3 Latissimus dorsi.

Trapezius: From occipital bone, nape ligament and spine as far as twelfth dorsal, to clavicle, acromion and ridge of shoulder blade.

Action: Extends head, elevates shoulder and rotates shoulder blade.

Deltoid, page 70 .

Latissimus dorsi, page 124.

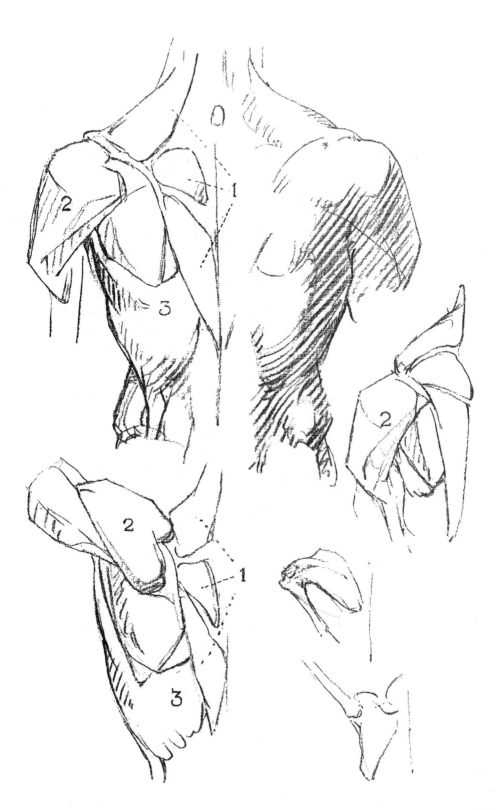

THE TRUNK

Trunk, back view

Anatomy

The trapezius is a diamond-shaped muscle; with upper apex at the base of the skull, lower apex well below the shoulder blades, and corners at the shoulder girdle opposite the deltoid, as though it were a continuation of that muscle.

From the sacrum the muscles diverge upward, while the lower ribs and lower corner of the shoulder blade diverge downward, making lesser diamonds of various definiteness of outline.

The ridge of the shoulder blade is always conspicuous, pointing diagonally toward the corner of the shoulder. It sets at a fixed angle with the spinal edge (more than a right angle) and at a right angle with the lower turned-out corner.

In relaxation, both ridge and blade are ridges under the skin, and are converted into grooves by the muscles bulging in contraction.

Of these muscles, those on either side of the ridge are easily recognizable—the deltoid, below and outside, and trapezius, above and inside, but the trapezius also spreads from the inner end of the ridge to well down the spine. Under this, helping to form the bulge, are the rhomboidei, extending from the blade diagonally upward to the spine, and the levator angula scapulæ, from its upper corner almost vertically to the top of the neck.

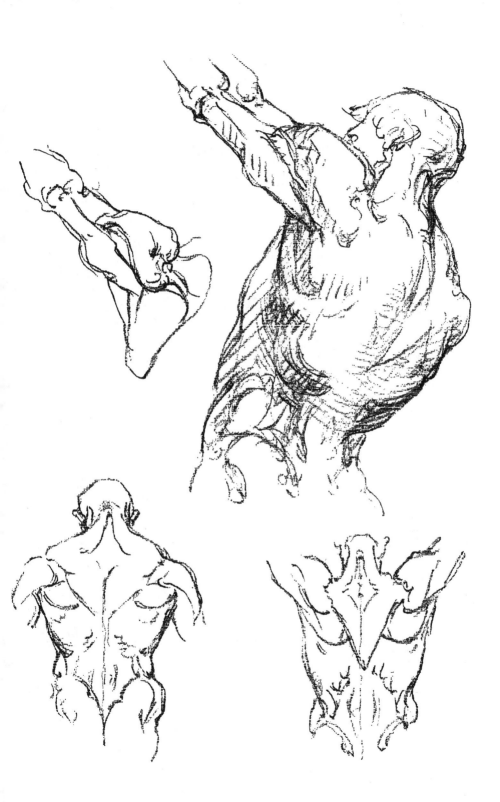

THE TRUNK

TRUNK, back view

MASSES AND THEIR MOVEMENTS:
TILTING AND TWISTING

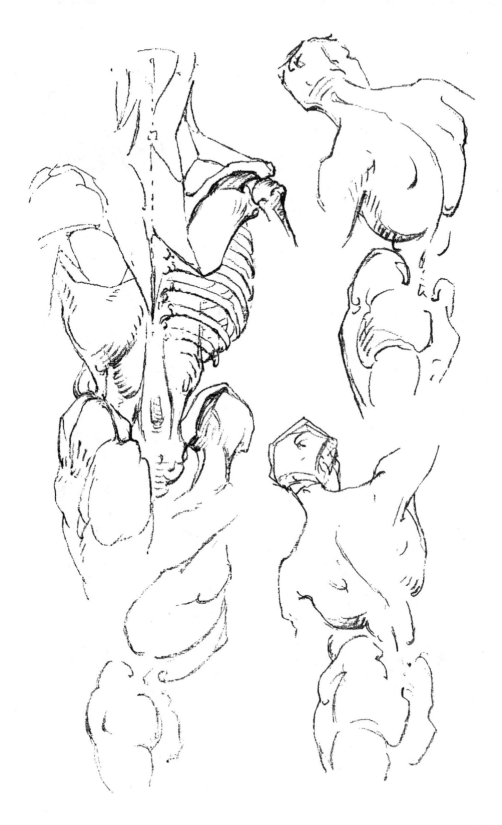

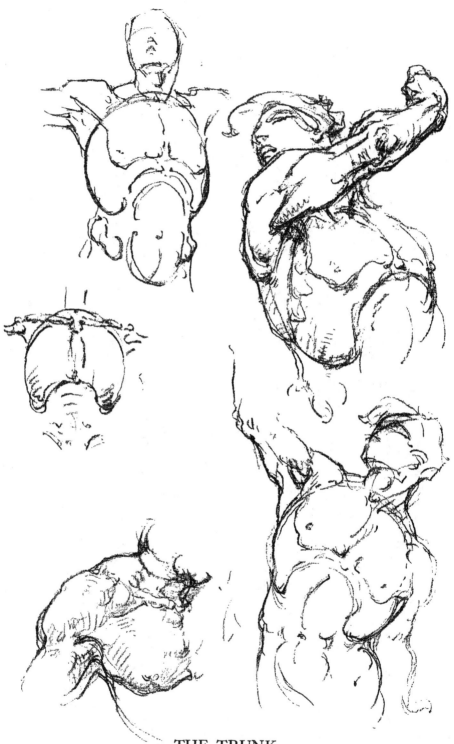

THE TRUNK

THE CAGE OF THE TORSE

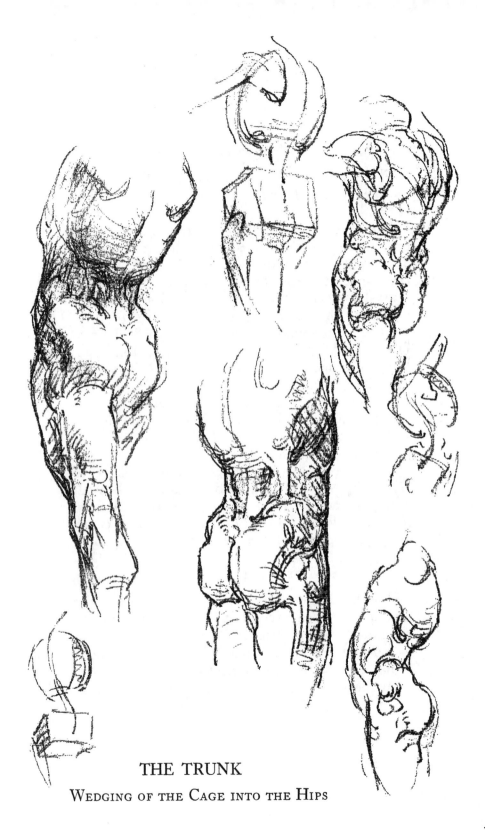

THE TRUNK

WEDGING OF THE CAGE INTO THE HIPS

The Pelvis

❁

Three bones make the pelvis; two innominate (without a name) bones and one sacrum (sacrificial bone).

The sacrum is a wedge about the size of the hand but more pefectly shaped, bent like a half-bent hand, and carrying a very small tip about as big as the last joint of the thumb (coccyx). It forms the central piece in the back, curving first back and down and then down and in.

The two innominate bones are formed like two propellers, with triangular blades twisted in opposite directions. The rear corners of the top blades meet the sacrum in the back, and the front corners of the lower blades meet in front to form the symphysis pubis. The hip socket itself forms the central point for the shaft. The two blades stand at right angles to each other.

The upper blade is called the ilium, the lower is called the pubis in front and the ischium behind, with an opening between. The only superficial parts are the top of the upper blade (iliac crest) and the front tip of the lower (symphysis pubis).

MASSES AND MARKINGS

The size of the pelvis is due to its position as the mechanical axis of the body; it is the fulcrum for the muscles of the trunk and legs, and is large in proportion. Its mass inclines a little forward, and is somewhat square as compared with the trunk above.

At the sides the ridge is called the iliac crest. It

is the fulcrum for the lateral muscles and flares out widely for that purpose; rather more widely in front than behind.

Above the rim is a roll of muscle belonging to the abdominal wall; immediately below it a groove or depression, made by the sag of the hip muscles, obliterated when these are contracted in action.

The Hip

❖

So great are the changes in surface form of the muscles in different positions of the hip that the iliac crest remains as the one stable landmark. It is a curve, but being beveled backward, it presents to the side view two lines and almost an angle between them at the top.

The posterior line is marked by two dimples where it joins the sacrum, and the line continues downward into the fold of the buttocks. From this whole line the gluteus maximus muscle passes down and forward, to just below the head of the thigh bone, making the mass of the buttocks and hip.

Just in front of this, from the top of the crest, descends the gluteus medius muscle, forming a wedge whose apex is at the head of the thigh bone. Between these two muscles is the dimple of the thigh.

Only part of the medius is superficial; its front portion is overlaid by the tensor fasciæ femoris muscle, which rises from the edge of the front line of the crest and descends to form with the gluteus maximus the wedge filled in by the medius. The two fasten to the dense plate of fascia that guards the outside of the thigh (ilio-tibial band). This

muscle is always prominent and changes its appearance greatly in different positions of the hip, forming a U-shaped wrinkle when the thigh is completely flexed.

On the front end of the crest is a small knob, from which descends the sartorius (tailor's) muscle, longest in the body. It forms a graceful curve as it lies in the groove of the inner side of the thigh, passing to under the knee.

From just below the knob, overlaid therefore by the sartorius, descends the rectus femoris muscle, straight to the knee cap.

From the knob, the line continues down and in to the symphysis, marking the boundary between abdomen and thigh.

The Pelvis and Hip

1 Tensor vaginæ femoris.

2 Sartorius.

3 Rectus femoris.

4 Gluteus medius.

5 Gluteus maximus.

Tensor
Sartorius } Page 142
Rectus femoris

Gluteus Medius: From ilium, outer surface, to femur, greater trochanter.
Action: Abducts and rotates inward thigh.

Gluteus maximus: From crest of ilium, rear portion, sacrum and coccyx to femur.
Action: Extends, rotates and turns out thigh.

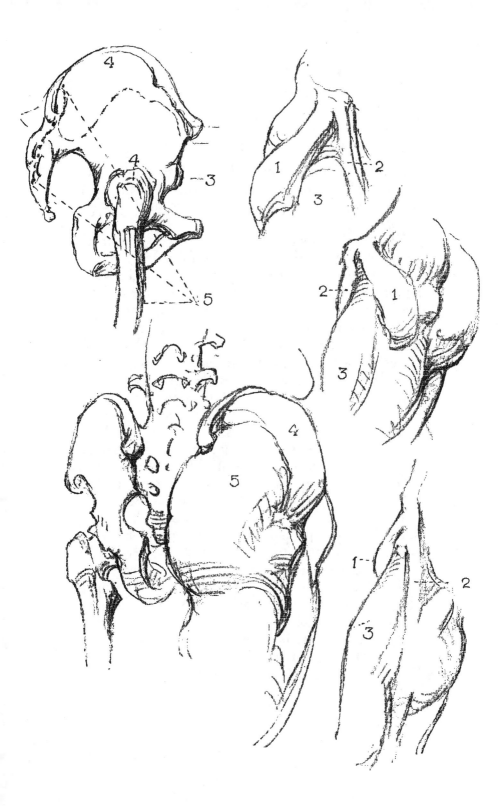

The Lower Limbs

❀

The lower limb is divided into three parts—the thigh, the leg, and the foot. These parts correspond to the arm, the forearm, and the hand of the upper limb.

The thigh extends from the pelvis to the knee, and the leg from the knee to the foot.

The longest and strongest bone of the body is the femur (thigh bone). It is joined to the bones of the pelvis at the hip socket by a long neck, which carries the shaft itself out beyond the widest part of the crest. From there the femora (thigh bones) converge as they approach the knees, bringing the knee under the hip socket. At the knee, the femur rests on the tibia (shin bone), the main bone of the leg, and makes a hinge joint. The tibia descends to form the inner ankle. Besides it, not reaching quite to the knee, is the fibula, the second bone of the leg, which descends to form the outer ankle. It is located on the outside, and is attached to the tibia at the top and bottom. These two bones are almost parallel. Above the juncture of the femur and tibia lies the patella (knee cap). This is a small bone almost triangular in shape. It is flat on its under side, and convex on the surface.

The great trochanter of the femur is the upper tip of the shaft which reaches up slightly beyond where the neck joins.

The lower portion of the femur widens to form two great hinge processes, known as tuberosities. They are on the outer and inner sides, and they are both visible.

The Thigh

❖

From the head of the femur (trochanter) to the
outside of the knee runs a band of tendon called the
ilio-tibial band. It makes a straight line from the
head of the thigh bone to the outside of the knee.

The rectus femoris muscle makes a slightly
bulging straight line from just below the iliac crest
to the knee cap.

On either side of the latter is a twin mass of
muscles. That of the outside (vastus externus)
makes one mass with it, and slightly overhangs the
ilio-tibial band outside. That of the inside (vastus
internus) bulges only in the lower third of the
thigh, and overhangs the knee on the inside.

Behind and inside of this is the groove of the
thigh occupied by the sartorius muscle, passing
from the ilium above to the back of the knee below.

Behind the groove is the heavy mass of the ad-
ductors, reaching two-thirds of the way down the
thigh.

Behind groove and adductors, around the back of
the thigh and to the ilio-tibial band outside, is the
mass of the ham-string muscles, whose tendons are
found on either side of the knee at the back. It is a
dual mass of muscle, dividing above the diamond-
shaped popliteal space at the back of the knee, whose
lower corner is formed by the gastrocnemius mus-
cle, similarly divided.

MASS

The mass of the thigh is inclined inward from
hip to knee, and is slightly beveled toward the knee
from front, back and outside.

The Leg

❁

Of the same width as the end of the thigh bone is the head of the tibia, or shin bone. Immediately below the head the shaft narrows on both sides, but on the outside and a little to the rear is the head of the fibula (which corresponds with the ulna of the forearm) more than filling out the narrowing on that side.

The ridge of the shin bone descends straight down the front of the leg, a sharp edge toward the outside, a flat surface toward the inside, which at the ankle bends in to become the inner ankle bone.

The outer bone of the foreleg (fibula) soon overlaid by a gracefully bulging muscular mass, emerges again to become the outer ankle bone.

On the back of the leg are two muscles. Beneath is the low, flat and broad soleus (sole fish) muscle; on top of it is the double-bellied calf muscle (gastrocnemius, frog's belly), covering its upper half, but crossing the knee joint above and helping to make the two knobs there. These two muscles unite to form the tendon of Achilles at the heel.

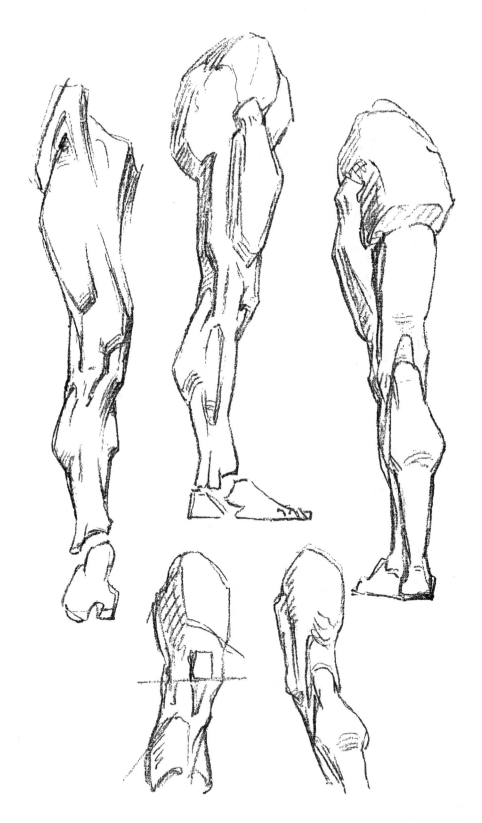

LOWER LIMBS

Bones of the Lower Limb:

Hip—Pelvis.
Thigh—Femur.
Leg—Tibia and Fibula (outside).

Muscles of the Lower Limb, front view:

1 Tensor of the fascia lata.
2 Sartorius.
3 Rectus femoris.
4 Vastus externus.
5 Vastus internus.
6 Tibialis anticus.
7 Peroneus longus.
8 Extensor longus digitorum.

Tensor Vaginæ Femoris (tensor fasciæ femoris):
From crest of ilium, front end, to fascia lata,
or ilio-tibial band.
Action: Tenses fascia and rotates inward thigh.

Sartorius: From spine to ilium in front to tibia
inside.
Action: Flexes, abducts and rotates inward thigh.

Rectus Femoris: From anterior inferior spine of
ilium to common tendon of patella.
Action: Extends leg.

Vastus Externus: From outer side of femur to
common tendon of patella.
Action: Extends and rotates outward leg.

Vastus Internus: From inner side of femur to
common tendon of patella.
Action: Extends and rotates inward leg.

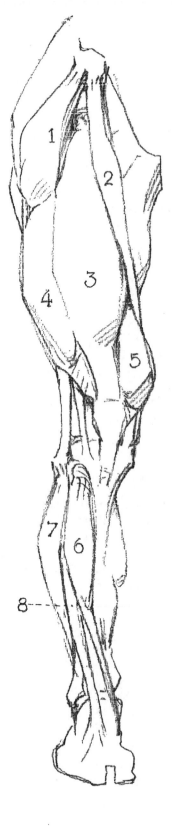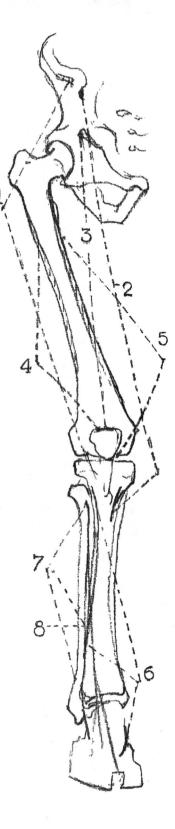

LOWER LIMBS

Muscles of the Lower Limb, back view:

1 Gluteus medius.

2 Gluteus maximus.

3 Semi-tendinosus.

4 Semi-membranosus.

5 Biceps femoris.

6 Gastrocnemius.

7 Soleus.

Gluteus medius
Gluteus maximus } Page 136

Semi-tendinosis: From ischial tuberosity to tibia.
Action: Flexes knee and rotates inward leg.

Semi-membranosus: From ischial tuberosity to tibia.
Action: Flexes knee and rotates leg inward.

Biceps Femoris: Long head from ischial tuberosity; short head from femur, to head of fibula.
Action: Flexes knee and rotates thigh outward.

Gastrocnemius, page 148.

Soleus, page 150.

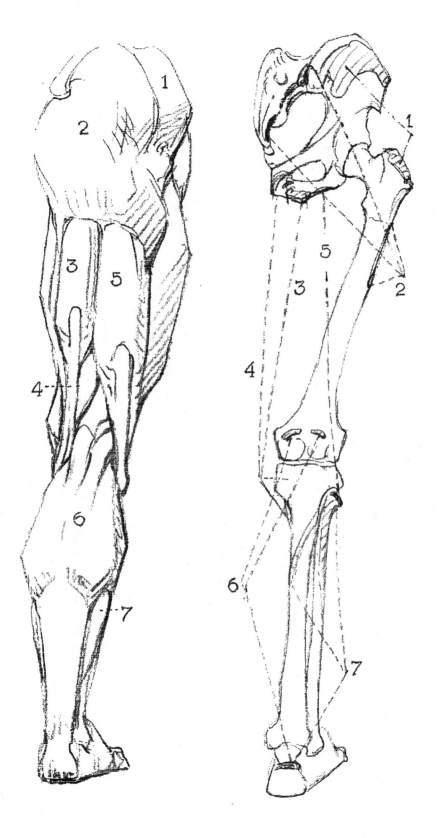

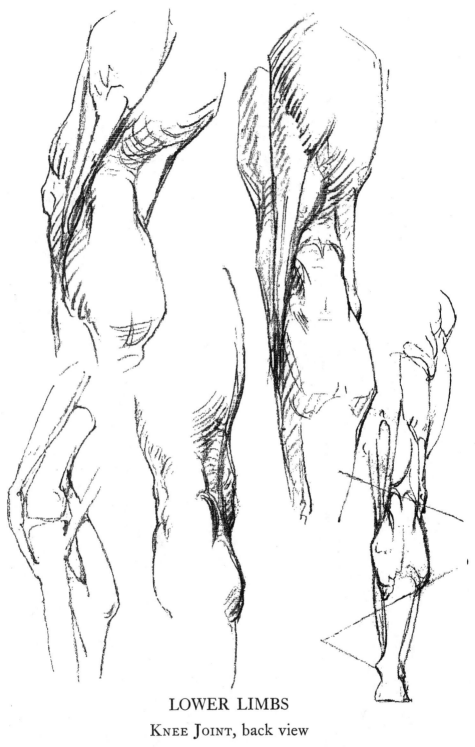

LOWER LIMBS

Knee Joint, back view

Ham-Strings, Gastrocnemius and Popliteal Space

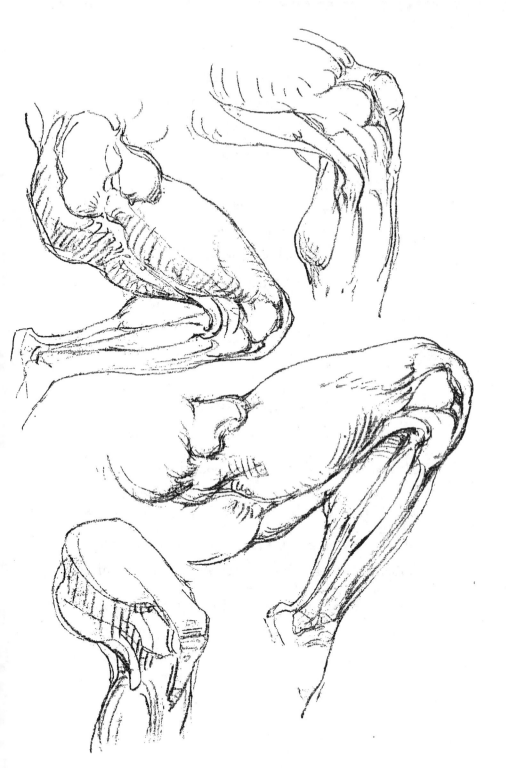

LOWER LIMBS

LOWER LIMBS

MUSCLES OF THE LOWER LIMB, outer view:

1 Gluteus maximus.

2 Gluteus medius.

3 Biceps femoris.

4 Vastus externus.

5 Gastrocnemius.

7 Tibialis anticus.

6 Peroneus longus.

BELOW THE KNEE

Gastrocnemius: From tuberosities of femur to tendon of Achilles.
Action: Extends foot, raises body in walking.

Peroneus Longus: From head and upper part of fibula passes beneath foot from outside, to base of big toe.
Action: Extends ankle and raises outer side of foot.

Tibialis Anticus: From upper and outer two-thirds of tibia to inner side of foot.
Action: Flexes ankle and raises inner side of foot.

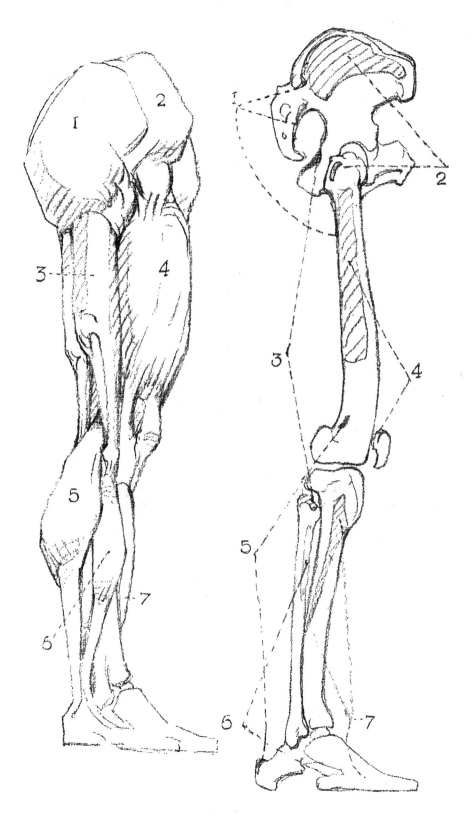

LOWER LIMBS

Muscles of the Lower Limb, inner view:

1 Rectus femoris.

2 Vastus internus.

3 Sartorius.

4 Gracilis.

5 Semi-tendinosus.

6 Semi-membranosus.

7 Gastrocnemius.

8 Soleus.

Below the Knee

Soleus: From upper part of fibula and back of tibia to tendon of Achilles.
Action: Extends foot and lifts body in walking.

Extensor Communis Digitorum (extensor longus digitorum pedis): From tibia and front of fibula to second and third phalanges of toes.
Action: Extends toes. Diagram, page 143.

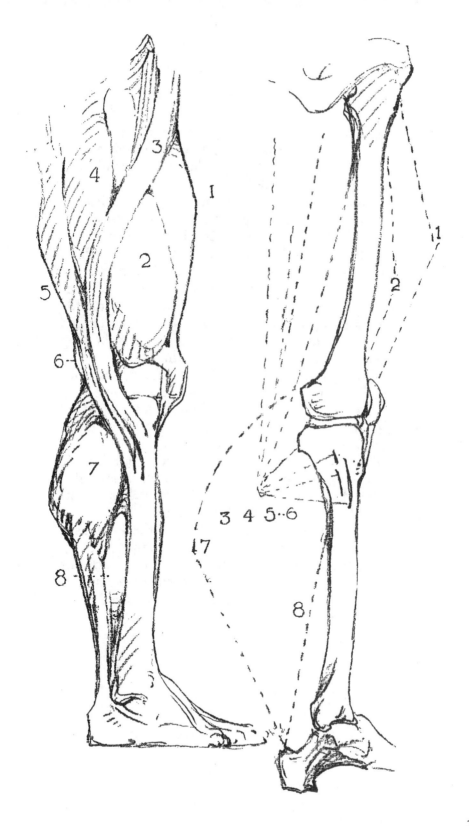

The Knee

❁

The knee must be thought of as a square with sides beveled forward, slightly hollowed at the back, and carrying in front the knee cap; like the stopper of an ink well.

A powerful ligament connects the cap with the high ridge of the shin bone below, the two sliding together on the end of the thigh bone, which is therefore exposed in flexion. The cap is always at the apex of the angle made by thigh and leg.

From the knee cap at the top rise the three muscles already described, the rectus by a tendon narrowing upward; the vastus externus by a tendon angling slightly out; the vastus internus bulging prominently from the corner of the cap.

When the knee is straight, its bursa, or water mattress, forms a bulge on either side in the corner between the cap and its tendon, exactly opposite the joint itself; the knee cap being always above the level of the joint.

The back, when bent, is hollowed out by the ham-string tendons on either side; when straight, the bone becomes prominent between them, making, with these tendons, three knobs.

The inside of the knee is larger; the knee as a whole is bent convex toward its fellow. The hip *socket*, the knee and the ankle are all in line; but the *shaft* of the thigh bone is carried some distance out by a long neck, so that the thigh is set at an angle with the leg.

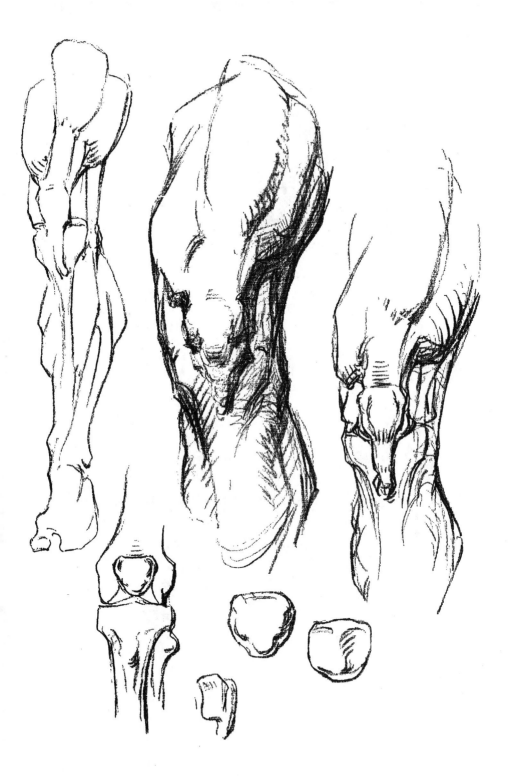

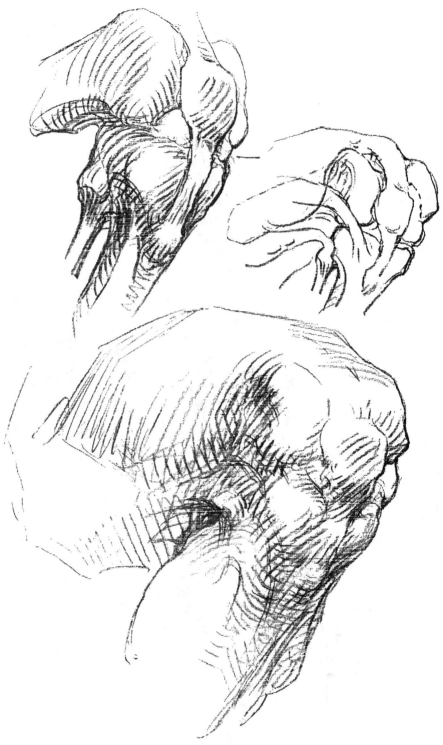

THE KNEE

Knee, outer view

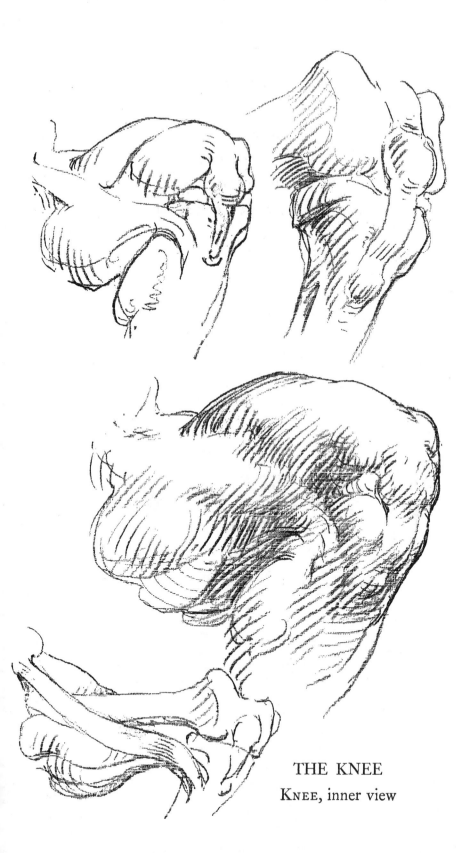

THE KNEE
Knee, inner view

THE KNEE

Knee:

1 Pad or sack.

2 Common tendon.

3 Patella or knee-pan.

4 Ligament of the patella.

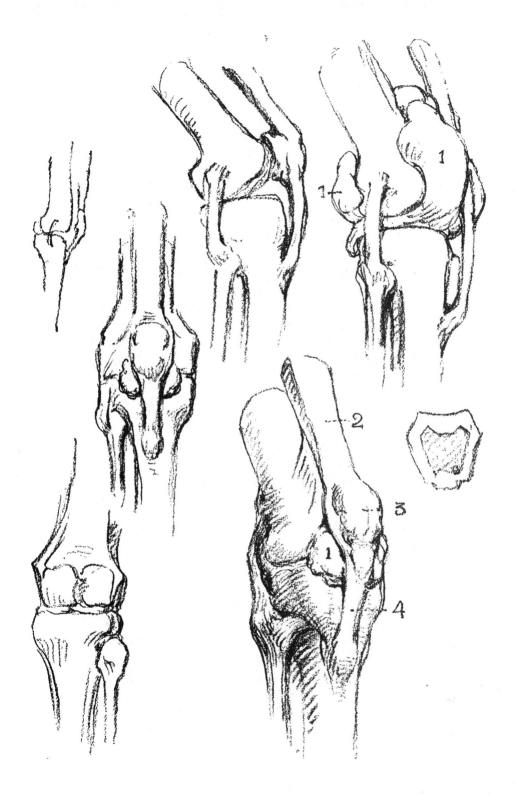

The Foot

❀

As the little finger side is the heel side of the hand, so the outside of the foot is the heel side. It is flat upon the ground, continuous with the heel; it is lower than the inside—even the outer ankle bone is lower—and it is shorter.

The inside, as though raised by the greater power of the great toe and the tendons of all the toes, is higher. To the front of the ankle is the knob that corresponds with the base of the thumb. Opposite it, on the outside, is a similar knob corresponding with the base of the little finger.

In the foot this symmetry adapted to the function of weight-bearing, has developed into a wonderful series of arches. The five arches of the foot converge on the heel; the toes being flying buttresses to them. The balls of the foot form a transverse arch. The inner arches of the foot are successively higher, forming half of a transverse arch whose completion is in the opposite foot. Opening gradually toward the ankle, this arching movement finally culminates in the two columns of the leg and the arch between; wherefore the leg is placed somewhat to the inside of the central line of the foot.

MOVEMENTS

In all positions, the foot tends to keep itself flat with the ground; the arches of the foot changing accordingly. In action, the foot comes almost into straight line with the leg, but when settling upon the ground, the outer or heel side strikes first and the whole foot settles toward the inside.

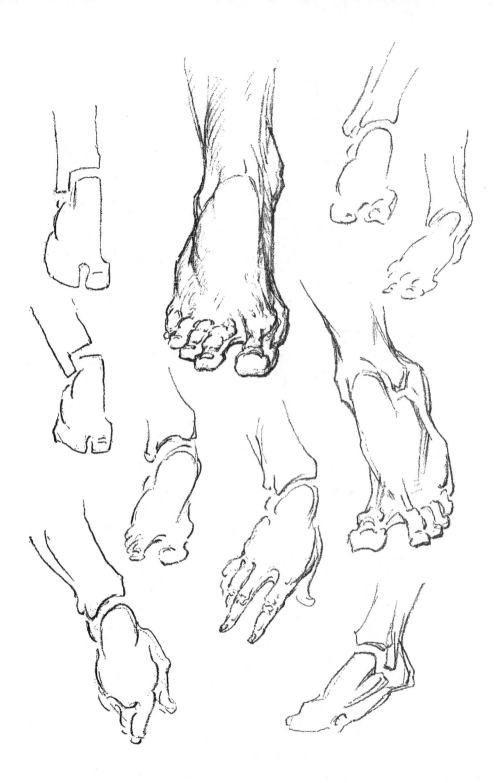

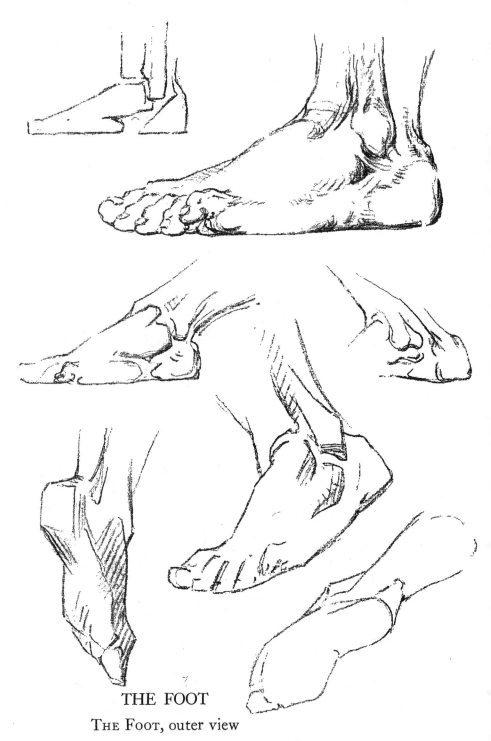

THE FOOT

The Foot, outer view

Interlocking of the Ankle with the Foot

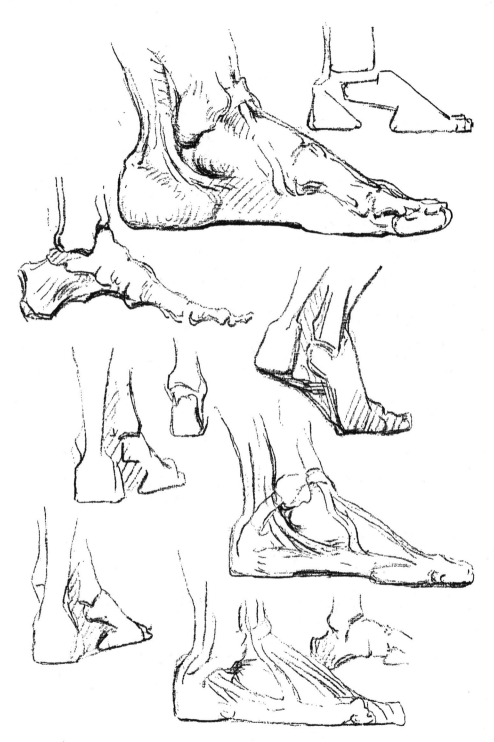

THE FOOT
The Foot, inner view

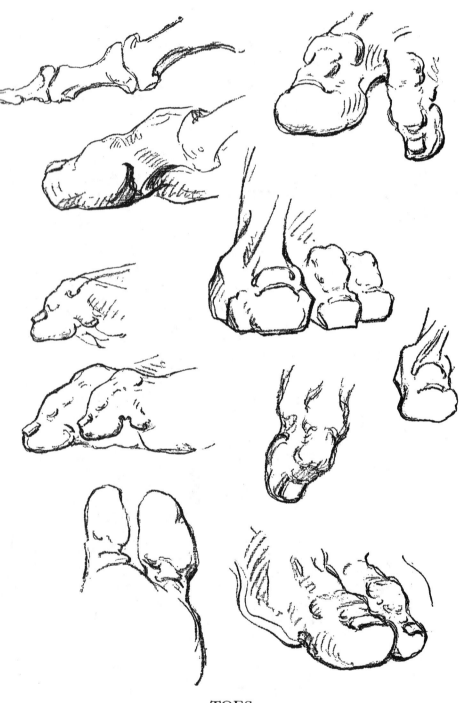

TOES

Their Pads and Wedging

ORIGIN AND COMMON MEANING
OF ANATOMICAL WORDS

Flexor	Bender
Extensor	Extender
Abductor	Drawing away (from median line)
Adductor	Drawing toward (median line)
Supinator	Turning face up
Pronator	Turning face down
Anterior	In front
Posterior	Behind
Longus	Long
Brevis	Brief, or short
External	Outside of
Internal	On inner side
Rectus	Straight
Vastus	Vast, or large
Minimus	Smallest
Semi	Half
Tertius	Third
Infra	Below

BONES

Frontal	In front
Temporal	"Time"
Parietal	From *paries,* wall
Occipital	From *ob,* over against, and *caput,* head; so back of head
Nasal	Nose
Malar	From *mala,* cheek
Maxillary	Jaw
Superior	Above, upper
Inferior	Below, lower
Mastoid	Nipple-shaped
Sternum	Breast bone
Clavicle	Key, collar bone
Scapula	Spade; shoulder blade
Humerus	Bone of upper arm

Ulna	Cubit
Radius	Spoke (of wheel)
Carpal	From *carpus*, wrist
Trapezium	Table
Trapezoid	Like a table—two sides parallel, two not
Scaphoid	Boat-shaped
Semi-lunar	Half-moon
Cuneiform	Wedge-shaped
Pisiform	Pea-shaped
Os magnum	Great bone
Metacarpals	Beyond the wrist
Phalanges	Ranks of soldiers
Digit	Finger
Os innominatum	Bone without a name
Sacrum	Sacred (used in oracles)
Coccyx	Cuckoo (beak of)
Femur	Thigh
Patella	Little pan
Tibia	Shin
Fibula	Flute
Calcaneum	From *calx*, heel
Tarsal	Instep
Metatarsal	Beyond the instep
Phalanges	Ranks of soldiers

MUSCLES

Temporal	Pertaining to temporal bone
Masseter	Chewer, masticator
Sterno-cleido-mastoid	Attaching to sternum, clavicle and mastoid bones
Thyroid	Shield (and *eidos*, like); so shield-like. (So all words ending in -oid.)
Thyroid cartilage	Adam's apple
Deltoid	Like Greek letter *delta*, triangular (equilateral)
Pectoralis	Pertaining to breast
Major	Greater
Minor	Lesser

Rectus abdominis	Straight muscle of abdomen
Oblique	Slanting
Serratus	Saw-toothed
Teres	Round
Biceps	Two-headed
Brachialis	Pertaining to arm
Anticus	(Adjective) in front
Triceps	Three-headed
Anconeus	Donkey's foot
Coraco-brachialis	From coracoid (beak-like) process of scapula to brachium, or arm
Gluteus	Buttocks
Maximus	Greatest
Medius	Middle-sized
Minimus	Smallest
Tensor	Tightener, or holder
Fascia	Band
Lata	Broad
Rectus femoris	Straight muscle of the femur
Vastus externus	Great muscle outside
Vastus internus	Great muscle inside
Abductor	Drawing away (from median line)
Gracilis	Slender, graceful
Semi-tendinosus	Half tendinous
Semi-membranosus	Half membranous (broad, flat tendon)
Plantaris	Of the sole of the foot (compare palmaris of the hand)
Gastrocnemius	Frog's belly
Soleus	Sole fish, or flounder
Achilles' tendon	The tendon by which Achilles' mother held in dipping him into the River Styx to make him invulnerable
Peroneus	Pin—another name for fibula
Tibialis Anticus	In front of tibia
Pollicis	From *pollex*, thumb or big toe
Thenar	Palm
Hypo-thenar	Under (less than) the thenar

Palmaris	Of the palm
Trapezius	Table-shaped
Latissimus dorsi	Broadest muscle of back
Infra-spinatus	Below the spine (of scapula)
Supra-spinatus	Above the spine (of scapula)
Teres major	Larger round muscle
Teres minor	Smaller round muscle
Rhomboideus	Rhomb shaped—quadrilateral but not right-angled

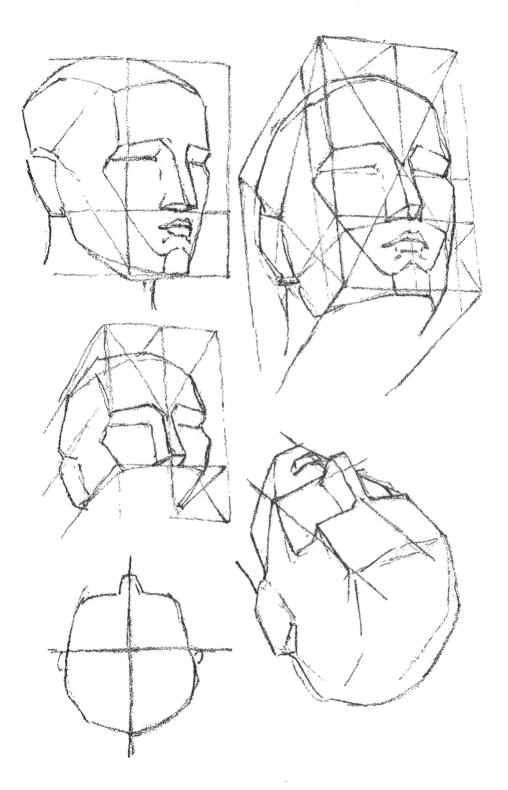

INDEX

Origin, Insertion and Action
of Muscles

A CATALOG OF SELECTED

DOVER BOOKS

IN ALL FIELDS OF INTEREST

A CATALOG OF SELECTED DOVER
BOOKS IN ALL FIELDS OF INTEREST

CONCERNING THE SPIRITUAL IN ART, Wassily Kandinsky. Pioneering work by father of abstract art. Thoughts on color theory, nature of art. Analysis of earlier masters. 12 illustrations. 80pp. of text. 5⅜ x 8½. 0-486-23411-8

CELTIC ART: The Methods of Construction, George Bain. Simple geometric techniques for making Celtic interlacements, spirals, Kells-type initials, animals, humans, etc. Over 500 illustrations. 160pp. 9 x 12. (Available in U.S. only.) 0-486-22923-8

AN ATLAS OF ANATOMY FOR ARTISTS, Fritz Schider. Most thorough reference work on art anatomy in the world. Hundreds of illustrations, including selections from works by Vesalius, Leonardo, Goya, Ingres, Michelangelo, others. 593 illustrations. 192pp. 7⅛ x 10¼. 0-486-20241-0

CELTIC HAND STROKE-BY-STROKE (Irish Half-Uncial from "The Book of Kells"): An Arthur Baker Calligraphy Manual, Arthur Baker. Complete guide to creating each letter of the alphabet in distinctive Celtic manner. Covers hand position, strokes, pens, inks, paper, more. Illustrated. 48pp. 8¼ x 11. 0-486-24336-2

EASY ORIGAMI, John Montroll. Charming collection of 32 projects (hat, cup, pelican, piano, swan, many more) specially designed for the novice origami hobbyist. Clearly illustrated easy-to-follow instructions insure that even beginning papercrafters will achieve successful results. 48pp. 8¼ x 11. 0-486-27298-2

BLOOMINGDALE'S ILLUSTRATED 1886 CATALOG: Fashions, Dry Goods and Housewares, Bloomingdale Brothers. Famed merchants' extremely rare catalog depicting about 1,700 products: clothing, housewares, firearms, dry goods, jewelry, more. Invaluable for dating, identifying vintage items. Also, copyright-free graphics for artists, designers. Co-published with Henry Ford Museum & Greenfield Village. 160pp. 8¼ x 11. 0-486-25780-0

THE ART OF WORLDLY WISDOM, Baltasar Gracian. "Think with the few and speak with the many," "Friends are a second existence," and "Be able to forget" are among this 1637 volume's 300 pithy maxims. A perfect source of mental and spiritual refreshment, it can be opened at random and appreciated either in brief or at length. 128pp. 5⅜ x 8½. 0-486-44034-6

JOHNSON'S DICTIONARY: A Modern Selection, Samuel Johnson (E. L. McAdam and George Milne, eds.). This modern version reduces the original 1755 edition's 2,300 pages of definitions and literary examples to a more manageable length, retaining the verbal pleasure and historical curiosity of the original. 480pp. 5⁵⁄₁₆ x 8¼. 0-486-44089-3

ADVENTURES OF HUCKLEBERRY FINN, Mark Twain, Illustrated by E. W. Kemble. A work of eternal richness and complexity, a source of ongoing critical debate, and a literary landmark, Twain's 1885 masterpiece about a barefoot boy's journey of self-discovery has enthralled readers around the world. This handsome clothbound reproduction of the first edition features all 174 of the original black-and-white illustrations. 368pp. 5⅜ x 8½. 0-486-44322-1

THE CLARINET AND CLARINET PLAYING, David Pino. Lively, comprehensive work features suggestions about technique, musicianship, and musical interpretation, as well as guidelines for teaching, making your own reeds, and preparing for public performance. Includes an intriguing look at clarinet history. "A godsend," *The Clarinet,* Journal of the International Clarinet Society. Appendixes. 7 illus. 320pp. 5⅜ x 8½. 0-486-40270-3

HOLLYWOOD GLAMOR PORTRAITS, John Kobal (ed.). 145 photos from 1926-49. Harlow, Gable, Bogart, Bacall; 94 stars in all. Full background on photographers, technical aspects. 160pp. 8⅜ x 11¼. 0-486-23352-9

THE RAVEN AND OTHER FAVORITE POEMS, Edgar Allan Poe. Over 40 of the author's most memorable poems: "The Bells," "Ulalume," "Israfel," "To Helen," "The Conqueror Worm," "Eldorado," "Annabel Lee," many more. Alphabetic lists of titles and first lines. 64pp. 5⁵⁄₁₆ x 8¼. 0-486-26685-0

PERSONAL MEMOIRS OF U. S. GRANT, Ulysses Simpson Grant. Intelligent, deeply moving firsthand account of Civil War campaigns, considered by many the finest military memoirs ever written. Includes letters, historic photographs, maps and more. 528pp. 6⅛ x 9¼. 0-486-28587-1

ANCIENT EGYPTIAN MATERIALS AND INDUSTRIES, A. Lucas and J. Harris. Fascinating, comprehensive, thoroughly documented text describes this ancient civilization's vast resources and the processes that incorporated them in daily life, including the use of animal products, building materials, cosmetics, perfumes and incense, fibers, glazed ware, glass and its manufacture, materials used in the mummification process, and much more. 544pp. 6¹⁄₈ x 9¹⁄₄. (Available in U.S. only.) 0-486-40446-3

RUSSIAN STORIES/RUSSKIE RASSKAZY: A Dual-Language Book, edited by Gleb Struve. Twelve tales by such masters as Chekhov, Tolstoy, Dostoevsky, Pushkin, others. Excellent word-for-word English translations on facing pages, plus teaching and study aids, Russian/English vocabulary, biographical/critical introductions, more. 416pp. 5⅜ x 8½. 0-486-26244-8

PHILADELPHIA THEN AND NOW: 60 Sites Photographed in the Past and Present, Kenneth Finkel and Susan Oyama. Rare photographs of City Hall, Logan Square, Independence Hall, Betsy Ross House, other landmarks juxtaposed with contemporary views. Captures changing face of historic city. Introduction. Captions. 128pp. 8¼ x 11. 0-486-25790-8

NORTH AMERICAN INDIAN LIFE: Customs and Traditions of 23 Tribes, Elsie Clews Parsons (ed.). 27 fictionalized essays by noted anthropologists examine religion, customs, government, additional facets of life among the Winnebago, Crow, Zuni, Eskimo, other tribes. 480pp. 6⅛ x 9¼. 0-486-27377-6

TECHNICAL MANUAL AND DICTIONARY OF CLASSICAL BALLET, Gail Grant. Defines, explains, comments on steps, movements, poses and concepts. 15-page pictorial section. Basic book for student, viewer. 127pp. 5⅜ x 8½. 0-486-21843-0

THE MALE AND FEMALE FIGURE IN MOTION: 60 Classic Photographic Sequences, Eadweard Muybridge. 60 true-action photographs of men and women walking, running, climbing, bending, turning, etc., reproduced from rare 19th-century masterpiece. vi + 121pp. 9 x 12. 0-486-24745-7

PSYCHOLOGY OF MUSIC, Carl E. Seashore. Classic work discusses music as a medium from psychological viewpoint. Clear treatment of physical acoustics, auditory apparatus, sound perception, development of musical skills, nature of musical feeling, host of other topics. 88 figures. 408pp. 5⅜ x 8½. 0-486-21851-1

LIFE IN ANCIENT EGYPT, Adolf Erman. Fullest, most thorough, detailed older account with much not in more recent books, domestic life, religion, magic, medicine, commerce, much more. Many illustrations reproduce tomb paintings, carvings, hieroglyphs, etc. 597pp. 5⅜ x 8½. 0-486-22632-8

SUNDIALS, Their Theory and Construction, Albert Waugh. Far and away the best, most thorough coverage of ideas, mathematics concerned, types, construction, adjusting anywhere. Simple, nontechnical treatment allows even children to build several of these dials. Over 100 illustrations. 230pp. 5⅜ x 8½. 0-486-22947-5

THEORETICAL HYDRODYNAMICS, L. M. Milne-Thomson. Classic exposition of the mathematical theory of fluid motion, applicable to both hydrodynamics and aerodynamics. Over 600 exercises. 768pp. 6⅛ x 9¼. 0-486-68970-0

OLD-TIME VIGNETTES IN FULL COLOR, Carol Belanger Grafton (ed.). Over 390 charming, often sentimental illustrations, selected from archives of Victorian graphics—pretty women posing, children playing, food, flowers, kittens and puppies, smiling cherubs, birds and butterflies, much more. All copyright-free. 48pp. 9¼ x 12¼. 0-486-27269-9

PERSPECTIVE FOR ARTISTS, Rex Vicat Cole. Depth, perspective of sky and sea, shadows, much more, not usually covered. 391 diagrams, 81 reproductions of drawings and paintings. 279pp. 5⅜ x 8½. 0-486-22487-2

DRAWING THE LIVING FIGURE, Joseph Sheppard. Innovative approach to artistic anatomy focuses on specifics of surface anatomy, rather than muscles and bones. Over 170 drawings of live models in front, back and side views, and in widely varying poses. Accompanying diagrams. 177 illustrations. Introduction. Index. 144pp. 8⅜ x11¼. 0-486-26723-7

GOTHIC AND OLD ENGLISH ALPHABETS: 100 Complete Fonts, Dan X. Solo. Add power, elegance to posters, signs, other graphics with 100 stunning copyright-free alphabets: Blackstone, Dolbey, Germania, 97 more—including many lower-case, numerals, punctuation marks. 104pp. 8⅛ x 11. 0-486-24695-7

THE BOOK OF WOOD CARVING, Charles Marshall Sayers. Finest book for beginners discusses fundamentals and offers 34 designs. "Absolutely first rate . . . well thought out and well executed."—E. J. Tangerman. 118pp. 7¾ x 10⅝. 0-486-23654-4

ILLUSTRATED CATALOG OF CIVIL WAR MILITARY GOODS: Union Army Weapons, Insignia, Uniform Accessories, and Other Equipment, Schuyler, Hartley, and Graham. Rare, profusely illustrated 1846 catalog includes Union Army uniform and dress regulations, arms and ammunition, coats, insignia, flags, swords, rifles, etc. 226 illustrations. 160pp. 9 x 12. 0-486-24939-5

WOMEN'S FASHIONS OF THE EARLY 1900s: An Unabridged Republication of "New York Fashions, 1909," National Cloak & Suit Co. Rare catalog of mail-order fashions documents women's and children's clothing styles shortly after the turn of the century. Captions offer full descriptions, prices. Invaluable resource for fashion, costume historians. Approximately 725 illustrations. 128pp. 8⅜ x 11¼. 0-486-27276-1

LIGHT AND SHADE: A Classic Approach to Three-Dimensional Drawing, Mrs. Mary P. Merrifield. Handy reference clearly demonstrates principles of light and shade by revealing effects of common daylight, sunshine, and candle or artificial light on geometrical solids. 13 plates. 64pp. 5⅜ x 8½. 0-486-44143-1

ASTROLOGY AND ASTRONOMY: A Pictorial Archive of Signs and Symbols, Ernst and Johanna Lehner. Treasure trove of stories, lore, and myth, accompanied by more than 300 rare illustrations of planets, the Milky Way, signs of the zodiac, comets, meteors, and other astronomical phenomena. 192pp. 8⅜ x 11.
0-486-43981-X

JEWELRY MAKING: Techniques for Metal, Tim McCreight. Easy-to-follow instructions and carefully executed illustrations describe tools and techniques, use of gems and enamels, wire inlay, casting, and other topics. 72 line illustrations and diagrams. 176pp. 8¼ x 10⅞. 0-486-44043-5

MAKING BIRDHOUSES: Easy and Advanced Projects, Gladstone Califf. Easy-to-follow instructions include diagrams for everything from a one-room house for bluebirds to a forty-two-room structure for purple martins. 56 plates; 4 figures. 80pp. 8¾ x 6⅜. 0-486-44183-0

LITTLE BOOK OF LOG CABINS: How to Build and Furnish Them, William S. Wicks. Handy how-to manual, with instructions and illustrations for building cabins in the Adirondack style, fireplaces, stairways, furniture, beamed ceilings, and more. 102 line drawings. 96pp. 8¾ x 6⅜. 0-486-44259-4

THE SEASONS OF AMERICA PAST, Eric Sloane. From "sugaring time" and strawberry picking to Indian summer and fall harvest, a whole year's activities described in charming prose and enhanced with 79 of the author's own illustrations. 160pp. 8¼ x 11. 0-486-44220-9

THE METROPOLIS OF TOMORROW, Hugh Ferriss. Generous, prophetic vision of the metropolis of the future, as perceived in 1929. Powerful illustrations of towering structures, wide avenues, and rooftop parks—all features in many of today's modern cities. 59 illustrations. 144pp. 8¼ x 11. 0-486-43727-2

THE PATH TO ROME, Hilaire Belloc. This 1902 memoir abounds in lively vignettes from a vanished time, recounting a pilgrimage on foot across the Alps and Apennines in order to "see all Europe which the Christian Faith has saved." 77 of the author's original line drawings complement his sparkling prose. 272pp. 5⅜ x 8½.
0-486-44001-X

THE HISTORY OF RASSELAS: Prince of Abissinia, Samuel Johnson. Distinguished English writer attacks eighteenth-century optimism and man's unrealistic estimates of what life has to offer. 112pp. 5⅜ x 8½. 0-486-44094-X

A VOYAGE TO ARCTURUS, David Lindsay. A brilliant flight of pure fancy, where wild creatures crowd the fantastic landscape and demented torturers dominate victims with their bizarre mental powers. 272pp. 5⅜ x 8½. 0-486-44198-9

Paperbound unless otherwise indicated. Available at your book dealer, online at **www.doverpublications.com**, or by writing to Dept. GI, Dover Publications, Inc., 31 East 2nd Street, Mineola, NY 11501. For current price information or for free catalogs (please indicate field of interest), write to Dover Publications or log on to **www.doverpublications.com** and see every Dover book in print. Dover publishes more than 500 books each year on science, elementary and advanced mathematics, biology, music, art, literary history, social sciences, and other areas.